PHOTOGRAPHY:
TURNING PRO

TOM GRILL

MARK SCANLON

AMPHOTO
American Photographic Book Publishing
An Imprint of Watson-Guptill Publications
New York, New York

Acknowledgement

We wish to acknowledge and express our appreciation for the talent, dedication, and goodwill contributed by our associate, Michael Stuckey, during the course of the preparation of this and our other books.

First published in New York, New York by American Photographic Book Publishing: an imprint of Watson-Guptill Publications, a division of Billboard Publications, Inc., 1515 Broadway, New York, NY 10036.

Designed by Tom Grill.

Library of Congress Cataloging in Publication Data

Grill, Tom, 1944–
 Photography, turning pro.
 Bibliography: p.
 Includes index.
 1. Photography—Business methods.
2. Photography, Commercial. 3. Photography, Journalistic. I. Scanlon, Mark, 1945– . II. Title.
TR581.G74 770'.68 82-1815
ISBN 0-8174-5517-5 AACR2

Manufactured in the United States of America.

1 2 3 4 5 6 7 8 9/87 86 85 84 83 82

CONTENTS

1. Assignment Photography: What's It Like? 9
• The rewards of assignment photography
• The drawbacks of professional photography • Do you have the necessary character traits?

2. A Four-Stage Plan for Turning Pro 17
• Stage 1: Choose a field • Stage 2: Secure a financial base • Stage 3: Develop a clientele • Stage 4: Set goals for your business

3. Business Basics 35
• Your image • Business stationery • The legal form of your business • Other preliminary procedures • Your credit rating and credit line • Personal representatives ("reps")

4. Bookkeeping and Accounting 49
• Recording-keeping discipline • The tax year • Depreciation • Accounting method • Books of account • Double-entry bookkeeping • The chart of accounts • How the system works • Cash flow • Managing accounts receivable • Collecting delinquent accounts • Taxes • Managing expenses

5. Portfolios and Promotion 63
• What a portfolio does • The secret of a winning portfolio: Making an indelible impression • The "commercial" look • Assembling your first portfolio • Presenting your portfolio • Methods of presentation • Tear sheets • Portfolio carriers • Promotional pieces • Advertising

6. Dealing With Your Client 81
• Who *is* your client? • Arranging appointments • The interview • Negotiating a fee • Job estimates • Going rates for photographic assignments • Preparing to shoot • Layouts • During the shooting • Editing results • Billing the client • Reshoots

7. Stock Photography 99
• What *is* stock photography • What stock photography means to you as a professional photographer • How to produce marketable images • The aggressiveness factor: working at stock photography • Building up your files • Who owns the photograph? • How to market your stock photographs on your own • How to market your stock photographs through a rep • How to market your stock photographs through a stock photo agency • Choosing a stock photo agency • Agency contracts

8. Equipment 117
• Cameras and camera equipment • Film • Lighting equipment • Obtaining equipment • Accessories

9. The Studio 127
• Long-term leases versus short-term rentals • Leasing a studio • Agents • Raw space • Sub-leasing • Size requirements • Elevators • Ceilings • Windows • Darkroom • Security • Utilities • Color • Startup expenses • Running expenses • Renting studio space day by day

10. Shooting On Location 137
• Prepare a general checklist • Question the client closely • Settle financial matters early • Obtain a purchase order • Select the location • Learn all you can about the location and its environs • Decide what to bring and what to obtain locally • Arrange accommodations • Check the weather • Double-check everything before departure • Scout the location • Shoot extensively and prudently • During the return trip, protect your film • Process and deliver the film as quickly as possible

11. Supplies and Suppliers 147
• General guidelines • Props and propping • Hairdressers and makeup artists • Set building • Processing labs • Camera repair • Messengers • Models and model agencies • Booking professional models • Model fees • Model releases • A sample model release

12. Anatomy of an Assignment 159
• A day by day journal of an actual location assignment

Bibliography 173

Index 175

ASSIGNMENT PHOTOGRAPHY: WHAT'S IT LIKE?

1

We live in the age of the visual image. Although the written word and the spoken word will always have a place, pictures have in many ways become the dominant form of mass communication. And the people who create those images practice a skill that in many ways has come to symbolize the twentieth century.

Ever since the early 1800's when Fox Talbot in England and Joseph Niepce in France first began recording images of light, the photographer has enjoyed a special status in our society. At various times considered to be eccentrics and even mystics, photographers have persevered in their single-minded pursuit of memorable images. Today, professional photographers are admired for their skills and envied for the exciting lives many of them lead.

Many different branches of professional photography exist, but without question the most glamorous is assignment photography. If you are like many of the millions of photographers around the world who love photography, you too may have on occasion pictured yourself in the role of the camera-laden pro, confidently giving instructions to a beautiful model. The world of assignment photography *is* exciting, and for those who are successful at it, the personal and financial return it provides can be bountiful.

THE REWARDS OF ASSIGNMENT PHOTOGRAPHY

What attracts people to a career in assignment photography? For many, the primary attraction is the opportunity to be one's own boss. Assignment photographers

work on their own; their success is not based upon someone else's whims, but on the photographers' own talents and abilities to market them. Moreover, as an independent businessperson, an assignment photographer need not share his or her profits with someone else. If you are the type of person who values independence, you will find assignment photography extremely appealing.

Financial return • In the last few decades, the commercial use of photography has become ever more widespread. Everywhere you look on billboards, in magazines, on brochures, on packaging, on counter displays, on instruction sheets—everywhere—photography is being used to sell products. Nobody knows better than advertisers that the right photograph helps a product's sales and the wrong photograph hurts sales. Consequently, advertisers are willing to pay high fees to obtain the photographs that they want, and any photographer who can supply those photographs is in a strong position to demand that his or her efforts be generously rewarded. There is nothing unusual about a top assignment photographer receiving $3,000 for producing a single photograph.

Creative opportunities • Despite the emphasis on selling, commercial photography offers a photographer many creative opportunities. Producing a good commercial photograph is by no means a routine task. Those assignment photographers who achieve the greatest success are in demand because they add something special to their work. They know how to go beyond the specifics of their assignment and raise their images to the level of artistry. Any competent photographer can take a satisfactory photograph if he or she is given clear instructions. Imaginative photographers take those instructions, apply their best creative efforts, and present the client with images that are very much the product of the photographers' artistic skill.

Job satisfaction • Another reward of assignment photography is the opportunity it provides for people to incorporate their interests into their profession. The field of professional photography is so broad that everyone

must specialize at least to some extent. As a result, a sports enthusiast, for example, could become a sports photographer, or someone interested in science could specialize in scientific photography. Indeed, some photographers who have a very unique hobby—model building, for example—have been able to carve out very successful careers simply by applying their photographic talents to their hobbies.

Travel • Another attraction of assignment photography is the chance it offers for travel. Although many photographers work out of a studio, many others find that their assignments take them all over the world. Few other professions offer so many opportunities to travel at someone else's expense.

Above all else, most people who enter professional photography as a career do so because they found photography as a hobby to be *fun*. They see professional photography as a way not only to earn a living, but to do so in a profession they thoroughly enjoy. For such people, the opportunity to avoid the drudgery of a routine nine-to-five job is ample compensation for some of the drawbacks of the profession that must also be considered.

THE DRAWBACKS OF PROFESSIONAL PHOTOGRAPHY

For all the rewards professional photography offers, it also has shortcomings.

You are on your own • Not surprisingly, being your own boss has not only advantages, but also drawbacks. As an independent businessperson, you have nobody to make decisions for you. Just as you are responsible for your successes, so are you responsible for your failures. If you fail, the blame rests squarely on your shoulders; there are no excuses. Moreover, you receive none of the "fringe benefits" employers usually offer, such as health insurance, withholding tax, or paid vacation time.

Low security • In addition, the profession provides little in the way of short- or long-term security. If you

become injured and cannot work, your income ceases. If your business fails, you will probably not qualify for unemployment compensation. When you retire, you will have no pension unless you have made specific provisions for one.

No job equity • Just as important, photography provides no real "job equity." If you take a salaried position, as a bank teller, for instance, the experience you gain over the years becomes a valuable asset. Your salary increases in proportion to your time on the job, and if you change jobs, your new employer will give you credit for the years you have worked. Even if you change careers, a new employer will usually give you credit for your past job experiences. You have built up equity in your career.

As a professional photographer, there is no carryover into other professions. If you find after a few years that professional photography does not suit you, you approach the job market as a novice. Even within the field of photography, your value will be determined more by what you can do today than what you did yesterday. If photographic styles change but you do not, you will find yourself being given fewer and fewer assignments.

Difficult to become established • Although the demand for photography is enormous, the competition for jobs is fierce. The same attributes of assignment photography that attract you appeal equally to thousands of other photographers. For every assignment to be won, there are probably five photographers who will fight to get it.

Even when you are established, finding and maintaining clients are continuous battles. Advertisers are constantly inundated with calls from photographers looking for work, any one of whom will be quite happy to take your client from you. In addition, art directors, the people in an advertising agency who hand out photographic assignments, come and go. What at one time was a secure client can be lost when the art director leaves. No one enjoys the rigors of pursuing new clients, but it is a task that never ends.

Erratic demand • The amount of work available in commercial photography is not stable. To some extent, photography is a luxury that is subject to the fluctuations of a fickle market. When money is available, advertisers are more than willing to spend it. But when times are hard, photographers feel the squeeze first. There is always work for the top echelon, but beginning professionals can fail simply because of a weak economy.

Many distractions • As an assignment photographer, you will not be free to pursue photography exclusively, but you will also have to run a business. You will be responsible for meeting bookkeeping requirements, collecting and paying taxes, monitoring cash flow, hiring and firing employees and assistants, arranging for loans, invoicing clients, collecting accounts receivable, sending monthly statements of account, and all the other tasks associated with running an active business. You will be an independent businessperson, and the burden will lay heavily upon your shoulders to run your business honestly, efficiently, conscientiously, and intelligently. Anything else is likely to contribute significantly to your financial downfall.

DO YOU HAVE THE NECESSARY CHARACTER TRAITS?

For every profession certain personalities are more suitable than others. Photography is no exception. While no one can say with assurance that a particular combination of character traits will inevitably lead to either success or failure, some traits are certainly valuable. Below are some questions you should ask yourself to help you determine if your personality is likely to help or to hinder you in your career. After a careful self-assessment, if you find that in all honesty you must answer most of the questions with a "no," you should reconsider your decision to become a professional photographer and perhaps pursue a different career.

Do you thrive on independence? • You will be working on your own. If you rely on plenty of direction,

moral support, and praise, you are not likely to find it. You must be able to derive your satisfaction from within yourself and from the knowledge that you are your own boss. Eventually, you may win acknowledgment, accolades, and even awards, but when you are first starting out, you will be disappointed if you expect them.

Are you self-assured? • The people who hire you will often ask you for your opinion about the best way to take a photograph. You must be decisive and able to make recommendations confidently, without hemming and hawing. Creative judgments can be difficult to make; if you do not form opinions quickly, you will spend a substantial amount of time sweating nervously while an art director breathes down your neck.

Can you set realistic goals for yourself—and reach them? • You will be facing hard work, disappointments, frustrations, and perhaps periodic bouts of poverty. Unless you know where you want to go and have a reasonable plan for getting there, you will drift aimlessly from one assignment to another without making the effort to establish a steady, dependable clientele. Unless you know where you are going and can pursue your goals doggedly, frustration may well lead quickly to defeat.

Are you self-controlled? • During a shooting, you are in complete charge. You must direct everything, keep a myriad of details in mind, and above all else, produce the desired shot. You will always seem to be working under impossible deadlines. If you become easily rattled, you will lose command of the shooting, and disaster may result.

Are you organized? • As an assignment photographer, you will usually spend far more time preparing to take a photograph than actually shooting the photograph. You will be responsible for obtaining props, building sets, arranging for models, renting any needed equipment and many similar details. If you have trouble setting priorities, maintaining records, and observing a budget, you will quickly find yourself in serious trouble. Art directors rarely return with a second assignment for a disorganized photographer.

Are you personable? • You will be constantly working with people. Some people are not skilled at making small talk or tolerating the idiosyncracies of others. If you are easily annoyed and short-tempered, then your future is probably not too bright in assignment photography.

Are you prepared to make the commitment? • Until you are established, your every waking moment will be devoted to photography and building your business. When you are not improving your portfolio or preparing for an assignment, you will be out looking for assignments or keeping your skills sharp. On occasion you may have to devote limited resources to equipment you need rather than to a well-deserved vacation. Establishing any business is a demanding process; photography can be more demanding than most.

Our intent in suggesting this questioning process is not to discourage, but to forewarn you. Photography can be an exciting, satisfying profession. However, an axiom of business is that where there is no risk, there is little reward. By assuming the risks of assignment photography willingly but intelligently, you place yourself in a position to reap the substantial rewards that accrue to those with the talent and drive to achieve success. If you have the skills, can maintain an optimistic attitude, and are willing to follow a logical strategy, such as the one we offer in this book, the deck will be stacked in your favor, and your prospects for developing a successful career will be excellent.■

A FOUR-STAGE PLAN FOR TURNING PRO

2

As should be apparent from Chapter 1, if you are to prosper as an assignment photographer, you must approach your career in a logical manner with a carefully organized strategy for success clearly in mind. To that end, this chapter presents an overview of the steps required to develop your career as a professional photographer. Emphases are on making sound decisions even before you have acquired your first client, on ways to survive during the early stages of your career, and on running and building your business once it is launched. Once you understand the systematic approach involved, the remaining chapters will focus on the individual aspects of assignment photography that you will need to know to develop and nourish your career as you meet your clients' needs.

Stage 1: Choose a Field

The profession of photography is so broad that it encompasses many specialties and subspecialties. At the highest levels of assignment photography, specifically the New York City market, competition is so fierce that only highly specialized photographers can find work. The situation is substantially different in outlying areas, however, where photographers are routinely expected to work in a variety of different specialty fields. Nonetheless, early in your career you should select a field in which you devote most of your attention. Do not ignore other fields—you never know what a client will ask you to do—but by concentrating on one field and mastering it, you will develop a level of expertise that will provide you with a type of unique photographic identity that catches the eye of the people who hire assignment photographers.

"Commercial" versus "Editorial" • Assignment photography can be roughly divided into two broad categories based upon the way a photograph will be used: commercial and editorial. Photographs used in any way to promote the sale of a product or service are considered commercial. These include magazine and newspaper advertisements, billboard displays, product packaging or counter ("point of purchase") displays, brochures, flyers, and so on. Photographs used to support a publication's text are considered editorial. The best examples of editorial usages are photographs accompanying the articles in magazines, newspapers, corporate annual reports.

Perhaps the most striking difference between commercial and editorial assignments is the amount of money you can expect to receive. Almost without exception, photo buyers will pay more for commercial assignments than for editorial.

These two broad categories can be subdivided into a variety of photographic specialties. For our purposes, we will group all the various specialties into ten fields that conform closely to the career patterns assignment photographers tend to follow. Because the lines between fields are not sharp, a particular specialty might fall into more than one field at the same time, depending on the emphasis a photographer gives his or her work. For example, a photographer might specialize in corporate annual report photography exclusively or in industrial photography but spend part of his or her time taking photographs for annual reports. The fields as described do, however, illustrate the overall thrust of most assignment photographers' careers, and thus the discussion will be useful to you as you develop your own career.

Below are descriptions of the various fields. Before you study them, here are a few points to bear in mind.

Capitalize on your nonphotographic talents • An art director—the person most likely to give you an assignment—selects a particular photographer because something about that person's work strikes the art director as being exceptional. To the extent that you can make

yourself stand out from the hundreds of other photographers an art director might be considering, you will be helping yourself and your career.

Therefore, as you look over the fields described below, consider how you can mesh your talents and interests with photography. Are you an airplane pilot? Do you scuba dive? Do you enjoy assembling scale models? Each of these skills could have application to one or more fields of assignment photography and could provide you with a means of attracting clients.

For example, we know a professional who is torn between two loves: photography and skiing. By specializing in mountain photography and promoting himself imaginatively, he has developed a widespread reputation as the person to call on when a photograph involving skiing is needed. Even though he never leaves his beloved mountains, he works regularly for Manhattan art directors—and commands New York fees. By fixing his sights early on a specialty that relates to both his interest in photography and his favorite sport, he has developed a career that is lucrative, as well as fun.

Match your field with your personality • Because personality characteristics that are valuable in one field of photography may be a disadvantage in another field, try to match your personality to the field you are going to enter. There are no hard and fast rules, but here are some general guidelines.

If you are comfortable working with and directing people and do not mind pressure, the fields of illustration and fashion/beauty may be right for you. If you are meticulous and prefer working alone, look at still life photography. If you are forceful and aggressive, you might make a good photojournalist. If you have a good sense of design, architectural photography may suit your personality. If you can work fast and are adept at improvising, consider industrial photography, illustration, photojournalism, and annual reports as career fields.

The prime consideration is that you try to break into a field for which your personality is suited. You may be able

to find work in another field, but your level of enjoyment is likely to be low, and the quality of your work will consequently suffer.

Annual Reports

Once every year corporations are required by law to issue a report to stockholders. Many firms take great pains to make certain that their annual reports reflect an image of prosperity and pay photographers handsomely to produce photographs that enhance their image. In addition to the reports themselves, photographers often find work taking photographs for corporate brochures and public relations bulletins.

Annual report photographers may be called on to take portraits of a firm's officers, photograph machinery or employees at work, take an aerial view of an industrial complex, or produce a close-up view of a small component the company manufactures.

Special Skills Required—ability to work fast and under extreme pressure.

Outlets—corporate annual reports, corporate brochures, general public relations publications, slide shows.

Related Fields—skills in any other field may be useful, depending on the nature of a particular assignment.

Special Considerations—work is seasonal with assignments usually clustered from November through January.

Architecture

Architectural photographers shoot buildings to meet the promotional needs of architects in brochures and slide shows or to illustrate the appearance of a building for its owners.

Special Skills Required—use of large-format cameras for perspective control and extreme image sharpness; ability to use light to reveal form effectively.

Outlets—architectural firms and magazines, corporations, builders and building supply companies.

Related Fields—interiors, industrial.

Special Considerations—need to be near cities; photographer should be patient, precise, persistent, and appreciate architecture.

Some Important Characteristics of the Various Fields of Photography

(H = High; M = Medium; L = Low)

	Total # of photographers in field	Pay scale per assignment	Demand for photography in field	Availability of assignments relative to # photogs in field	Specialized skill requirement	Need for special equipment/ facilities
Annual Reports	M	M	L-M	M	M	M
Architecture	L	L-M	L	L-M	H	M
Fashion/ Beauty	H	M-H	M	L	M	L
Illustration	L	H	H	H	H	M
Industrial	M	M-H	M-H	M-H	M	M-H
Interiors	L	M	M-H	H	L	H
Photo-journalism	H	L	H	L	L-M	L
Sports	H	L	L	L	L-M	M
Still life	L-M	M-H	H	M-H	M	M-H
Travel	H	M	M	L	L	L

Fashion/Beauty	Fashion and beauty photographers shoot male and female clothing and cosmetics, including hair products, makeup, hand and nail products, and even fragrances.

Technical Skills Required—feel for current styles and photographic trends, mastery of both studio and outdoor lighting, ability to work with models.

Outlets—fashion magazines, magazine advertisements, catalogs, department store ads, some beauty salon work.

Related Fields—illustration (see below)

Special Considerations—clientele limited mostly to large cosmetic and pharmaceutical firms; need limited amount of equipment; highly competitive; very lucrative at high end, but not at low end; maintaining a current portfolio very important.

Illustration

Illustration photographers produce contrived settings containing people to tell a "story" with commercial value. For example, a family sitting around a table, a scene containing a Santa Claus, or a man working in an office is each the type of scene an illustration photographer might be called upon to produce.

Special Skills Required—ability to design and construct sets, mastery of studio lighting, ability to work with and direct people, ability to create "reality" in an artificial situation.

Outlets—magazines (both editorial and commercial usages), packaging, catalogs, annual reports, displays, brochures.

Related Fields—industrial, stock, fashion/beauty.

Special Considerations—is most difficult but most highly paid field of all, closely related to cinematography.

Industrial

Industrial photographers are called upon to photograph anything related to industry and manufacturing: machinery, industrial buildings, industrial processes, people working, etc.

Special Skills Required—ability to handle wide variety of different techniques including macrophotography, portraits, interiors, architecture, and the ability to light large rooms.

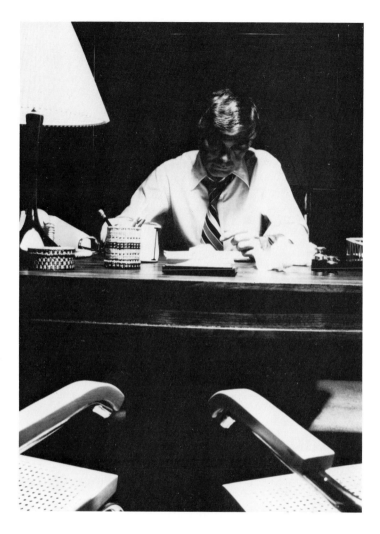

In illustration photography a photographer must use his or her talents to tell a story or illustrate an idea. The story may be simple or it may be complex, but the challenge is to make the point of the photograph immediately apparent.

The photo at left looks convincingly like a businessman working late at night. Actually, the scene was assembled with a substantial amount of effort in a photo studio. Attaining believable illustration photographs requires such a high level of skill that proficient illustration photographers are among the highest paid in the profession.

Outlets—any company is a potential client because all need photos of products or processes for brochures, advertising, packaging, and annual reports.

Related Fields—annual reports, architecture, interior, stock.

Special Considerations—requires a broader diversity of technical skills than any other field.

Interiors

Interior photographers concentrate on photographing room settings, including furniture, wall decorations, and appliances.

Special Skills—ability to handle large-format equipment; sometimes need to construct sets.

Outlets—department stores, furniture companies, magazines, interior decorators, architects, corporations.

Related Fields—architecture, industrial.

Special Considerations—very little competition; large amounts of expensive equipment required; difficult to develop a portfolio; only need a few basic setups to handle all types of assignments.

Photojournalism

Photojournalists shoot real-life events while they are occurring.

Technical Skills Required—ability to work with a limited amount of equipment (only what can be carried); ability to work in adverse lighting conditions.

Outlets—newspapers and magazines; wire services.

Related Fields—illustration, industrial, portraits, travel, stock.

Special Considerations—low pay, high pressure; declining opportunities as newspapers and magazines continue to fold; valuable to have own darkroom; field difficult to break into as a freelancer.

Sports

Sports photographers cover any activity related to either team or individual sports.

Technical Skills Required—familiarity with small- and medium-format photography; ability to interpret sports on film; skill at working in available light and under adverse weather conditions.

Outlets—magazines and newspapers, both editorially and commercially; advertising agencies via stock sales.

Related Fields—photojournalism, stock.

Special Considerations—low paying; can be fun for sports enthusiasts; market can be broad if stock sales are developed.

Still life photographers take photographs of inanimate objects. Living models may occasionally be included in a photograph, but their role is peripheral.

Technical Skills Required—ability to work in all formats, especially large formats; mastery of studio lighting; knowledge of many photographic "tricks" to make objects visually appealing.

Outlets—primarily advertising agencies, which use still life photographs of products in magazine and newspaper advertisements, brochures, and catalogs, as well as on billboards and packaging. Every product made needs at least one photograph taken of it.

Related Fields—industrial, some illustration.

Special Considerations—vast amounts of work; if you can afford specialized equipment, it's a good field for beginners because of comparatively low competition; can be very lucrative.

Sometimes a particular field is so limited in potential that you are well advised to start out in one field and use it to generate the money you need to enter another. For example, most of the work available in architectural photography is very low paying. At the same time, interior photography pays very well but requires a large studio and expensive equipment. By saving money from architectural photography you may be able to branch out into the other, potentially more rewarding field.

Stock
Stock photography is not so much a field as a marketing approach and, as such, encompasses all other fields. Stock photography is so important to every assignment photographer that we devote an entire chapter to it later (Chapter 7).

Travel
Travel photographers take photographs of specific places.

Technical Skills Required—none specifically related to the overall field.

Outlets—travel magazines, stock photo files, calendars, airlines, travel agencies.

Related Fields—photojournalism, stock.

Special Considerations—combines well with writing skill; highly competitive; necessary to carve out one's own market.

Select a field offering good opportunities • The chart on p. 21 provides additional information about each of the fields of photography discussed above. Your own circumstances will determine which field will be most attractive to you. Some of the column headings are self-explanatory, but some need further explanation.

The "Availability of assignments relative to the number of photographers in the field" indicates how saturated the field is with photographers. Fields with a low rating are highly competitive; fields with a high rating are wide open.

The "Specialized skill requirement" column indicates fields that are difficult for someone with relatively little photographic experience to break into.

The "Need for specialized equipment/facilities" column is important as a measure of the capital investment that a field will require. In the case of photographing interiors, very little skill is needed to establish a profitable clientele, but the large outlay for specialized equipment effectively bars the field to most photographers. (Because stock photography encompasses the other fields, it is not listed as a separate entry on the chart.)

Stage 2: Secure a financial base

Your long-term goal in choosing assignment photography for a career is to find plenty of work and ultimately to prosper, but at the outset the main challenge and your immediate goal will simply be to break even financially.

Your most immediate concern will be capital. You will need to buy equipment to use to complete assignments, you will incur expenses in the course of shooting assignments, and you will need money to live on until invoices are paid and your business is generating a profit. Some equipment you will have already, but you may need additional items depending upon the field you choose to enter. If you plan to devote your attention full time to your business, you will need to have enough money in the bank to operate your business and meet all your personal living expenses for at least six months. Otherwise, you may run out of cash before your income rises to meet your expenses.

Because of these high start-up and running costs, most young photographers arrange some means of interim support while they are establishing themselves. If you are in that position, for the sake of broadening your base of experience, do your best to support yourself in some area of photography, no matter how remote from your intended field. You might consider working for a while photographing weddings or taking portraits, or you might take a job in the graphics department of a newspaper or work in a photo lab. Every bit of experience you gain will someday stand you in good stead.

One approach many beginning photographers find extremely beneficial and satisfying is to work as a photographic assistant to an established professional photographer.

PHOTOGRAPHERS' ASSISTANTS

Except when shooting very small assignments, most professional photographers regularly hire assistants. An

assistant's function is to do anything the photographer asks that will help with the shooting. Most often the duties entail preparing sets, acquiring props, setting up lights, and assisting with management of the shooting itself. Working as an assistant can be an invaluable experience, especially if you can locate photographers to work for who are willing and able to help you learn.

The two types of assistant • There are two types of assistant: freelance and salaried. Freelance assistants work by the job for any photographer who will hire them, while salaried assistants work for only one photographer. There are advantages and disadvantages to each arrangement.

Freelance assistants earn more money than salaried assistants, but must pay their own taxes and provide their own fringe benefits. Freelancers work for a variety of different photographers and therefore are exposed to different photographic styles. In addition, freelancers have more free time to book assignments on their own. However, freelancers have little job security.

Salaried assistants have reliable jobs and fringe benefits, but are only exposed to a single photographer and do not have as much free time as freelancers. On the positive side, often a salaried assistant is allowed to use his or her employer's equipment and studio facilities for shooting assignments.

Finding work • You do not have to be an accomplished photographer to work as an assistant. More important to your employer than your photographic skill will be your ability to handle the equipment that will be used in a shooting. If you can take reliable exposure readings, handle a strobe unit, construct sets, and help with propping, your services will be in demand. The photographer has much at stake in a shooting; more valuable to him than anything else is having someone he can depend on to complete assigned tasks. Thus, in looking for work as an assistant, your goal should be to convince a photographer that you are reliable and will be helpful.

You can approach photographers directly in person or by phone. Obtain the names of prospects by looking in

the Yellow Pages. Stress in your presentations any special skills you have, such as carpentry or darkroom experience.

Be persistent • Often a photographer will already have found one or more assistants with whom he likes to work. Only if your call arrives at exactly the right time—for example, when he has just been given an assignment and has not yet lined up an assistant—will you be likely to be given work. Once you have worked for a few photographers and have established a good reputation, you will find that work abounds.

Do not be discouraged if your first round of contacts does not prove successful. Call back at regular intervals. Your persistence will be viewed favorably by photographers, who are always looking for people who know how to see a task through to completion despite obstacles.

One excellent tactic is to prepare a simple mailer. If you give photographers something to place on file, your name is likely to be on hand when a photographer suddenly needs an assistant. You will further enhance your position if you follow up your mailer with periodic phone calls.

Fees • The fees assistants receive vary from one location to another and are also dependent on skill and experience. In New York City as of this writing, a beginning assistant receives as little as $40 for a day's work, whereas proficient assistants command $75 per day or higher. Fees are lower in smaller cities.

When you are first starting out as an assistant, you must be willing to work at the low end of the pay scale. If you work hard and prove dependable, you will soon be able to raise your daily fee. As you successfully complete assignments, ask for references to make finding other jobs easier.

The key to success as an assistant is to make yourself indispensable. The more you can do to remove burdens—both mental and physical—from the photographer, the more he will value your help, and the more he will be willing to pay you. With a thousand details rolling around in his head, few things are more valuable to a photographer than a reliable assistant.

Learn whenever and whatever you can

• Whenever you work for another photographer, as either a freelance assistant or a salaried employee, seize every opportunity to learn as much as you possibly can. Observe what your employer does, ask questions, and make the effort to expand your mastery of photography. In addition, learn about how a photography business is run. Take advantage of your chance to learn at somebody else's expense. Every pitfall you can avoid later will save you time, money, and aggravation.

While you are meeting expenses by working as an assistant, you should simultaneously be putting together your portfolio, seeking your own assignments, and building a clientele. If you have established good relationships with some of the photographers you have worked for, you can approach them for advice when you run into problems. Once you have a few clients you can depend on for regular work, you will be in a position to ease yourself out of being an assistant and into developing your own career full-time.

Stage 3: Develop a clientele

Various aspects of the critically important task of identifying potential clients and convincing them that you are the person they want to hire are covered in several later chapters. Here, we want to discuss the broader concept of developing a clientele: that is, of establishing a base of clients who return to you time after time over a period of many years.

The process of acquiring new clients is tedious, and you probably could not run a successful business if you had to rely only on first-time accounts. In other words, your financial base will ultimately depend on your acquiring a group of clients on whom you can depend for regular work. Therefore, conduct your business as if you want every client to last forever. You cannot afford to lose any clients until you have more than you can handle.

Treat each client as a valued customer by doing your best to provide a level of service that will keep the client happy.

When a client first agrees to hire you for an assignment, he is taking a gamble. Obviously, he will not be giving you the assignment unless he believes that you will be able to complete it. But in every shooting you complete, you will still be on trial. Your goal must always be to convince a client that he has made the right decision in selecting you and that he will be smart to return to you for future assignments.

Does this mean that you must kowtow to the client's every whim? Certainly not. It does, however, suggest that you should conscientiously endeavor to show the client that you are the best person for the job. Here are some suggestions on how to do that.

Be the complete master of your equipment • Always remember that your client has every right to assume that you are technically competent. You are not being hired because you know how to attain a correct exposure; a thousand other photographers can do that. But if you *cannot* obtain a correct exposure or if you do not understand lighting or films or the relationship between focal length and depth of field or any of the thousands of other technical aspects of photography, you have no business selling your services. You should be the unquestioned master of your equipment. If you are not, then you should be devoting your efforts not to finding and satisfying clients, but to improving your basic skills.

Take your work seriously • No matter how foolish you may consider either the assignment or the product you are being asked to photograph, do not belittle either. Chances are that the person you are working with considers his or her project to be just as important as you consider your photography. Make fun of the product or the job, and you risk never seeing the client again.

Make no promises that you cannot keep, and keep all promises that you make • Your client will have more than enough problems without having to worry about whether you will do what you say you will

do. Keep accurate notes about what each job entails, and be absolutely certain that you do not overlook any tasks that you have agreed to perform. For example, if you say that you can provide a certain prop, be sure it is available and in good condition at the time of the shooting.

Make yourself indispensable • The more you can do for your client, the more valuable you will be to him or her. Particularly when you are first starting out, be willing to provide that little bit of extra service that shows initiative. Anticipate the questions he or she will have and be prepared with answers. Compile and maintain a list of stylists, hair and makeup artists, and modeling agencies from which you can make suggestions for particular jobs. Be willing to sit in on model interviews if the client asks you to. If you know ways the client can save money on a shooting, suggest them. The client will remember.

Be completely prepared by the time the shooting is designated to start • Nobody likes to be kept waiting. Moreover, many of the people involved in a shooting may be charging by the hour. An hour's delay caused because you are not prepared can cost a client hundreds and even thousands of extra dollars.

Keep careful records of your expenses, and be certain that your invoices are accurate • Even honest mistakes on your part call into question your integrity. Art directors change from agency to agency with great frequency. An indiscretion could become widely known and haunt you for years.

Clients will expect you to meet all your commitments professionally. To the extent that you do, you will develop a dependable stable of clients who return to you with assignments year after year.

Stage 4: Set goals for your business—and meet them

Think long-term • Businesses do not succeed by chance; they succeed because someone exerts a driving force that propels the business steadily forward. As the

number of assignments you fulfill in a month grows, you will probably find yourself so distracted by day-to-day concerns that you will not really know how your business is doing. Therefore, early in your career draw up a three-year plan containing a series of realistic goals to strive for. Divide the period into six-month intervals and decide for each period how many regular clients you should have, how large your income should be, and the amount of equipment you should own.

Having goals will help you focus your efforts and monitor your professional development effectively. At the end of the three-year period you can decide if you are doing the kind of work you want and if you should make any major changes.

As your business progresses, discipline yourself to keep your goals firmly in mind by reviewing them periodically. Scores of successful business people attest that the mere fact that they committed themselves in writing to a set of goals gave them a sense of direction that they otherwise would have lacked and that directly contributed to their success.

In addition, from the very start you should be learning about stock photography and building your stock files (see Chapter 7). Everywhere you go and every time you shoot an assignment you should also be thinking about stock. Eventually, the stock photographs alone could form a financial base that permits you to pick and choose among clients.

If you follow this four-step strategy, at the end of the three years your business will be well established and you should be standing on the threshold of a successful, satisfying career. ■

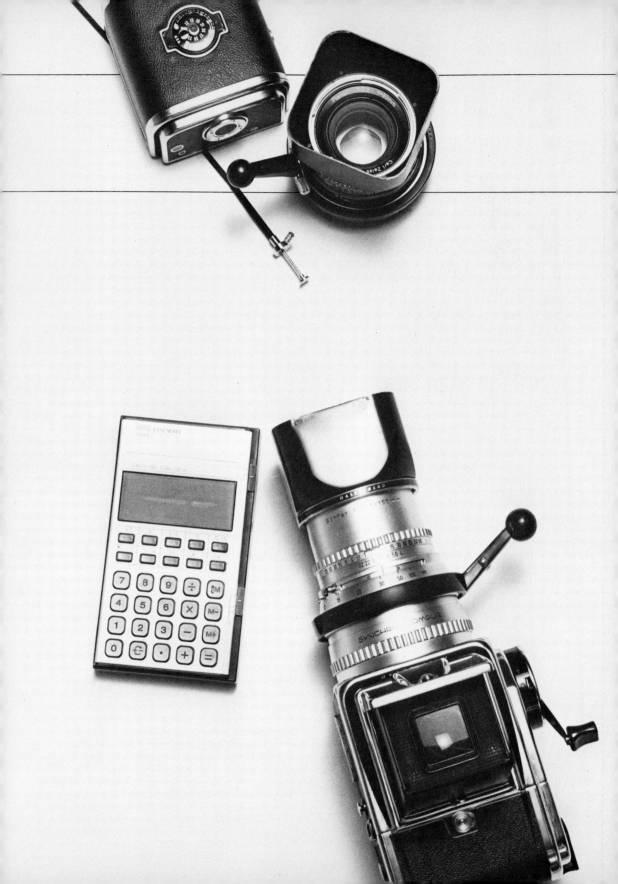

BUSINESS: BASICS

<div style="text-align: right">**3**</div>

YOUR IMAGE

As a professional assignment photographer, you are the head of a business, and you will be dealing primarily with executives from other businesses. If you expect to be taken seriously, treated with respect, and paid high fees, you must project an image of professional competence and personal substance to the business world. This is not to suggest that you should misrepresent yourself, but rather that you should present yourself in the most favorable light you can. Even when you are first starting out and your resources are limited, your best interests demand that you make the effort to develop a professional image. The following are some image-building suggestions you should consider.

The telephone • In many instances, the first impression you make on a potential client will be over the telephone. Make certain that that impression is positive.

The ideal is to have your own office and receptionist, but if you work out of your own home, have a separate business line to prevent social calls from being confused with business calls. If you have children, locate the phone where the sound of a child in the background can *never* be heard over the phone and establish a strict rule that the children are not to answer your business line.

Answering "hello" to a phone call makes you sound amateurish and insubstantial. Instead, say, "John Doe Photography," or "Jane Doe Studio," as appropriate. Instruct anyone who answers the phone for you to use the proper greeting, also.

If at all possible, you should either engage an answering service or use an automatic answering machine to handle incoming phone calls when you are away from your office. A phone that rings unanswered is very annoying to an art director who needs the answer to a question about a job.

Answering Services—Answering services, which are linked via telephone cables to your phone line, provide operators to answer calls placed to your number when you are not available. The primary advantage of an answering service is that the caller usually is not aware that he or she is talking to a service rather than a receptionist or secretary.

An answering service is only as good as the people it hires to answer the phones. Some let the phone ring too long before answering or employ operators with a disagreeable phone presence. Shop around for a service with operators who project a pleasing, competent phone manner. Once you have engaged a service, monitor their performance by phoning your own number occasionally to experience firsthand the manner in which they represent you to the outside world.

Answering Machines—When automatic answering machines were first introduced, they suffered from a stigma that they have only recently overcome. Today, although still less desirable than a receptionist or answering service, answering machines are at least acceptable. The key to their usefulness, however, lies in the way you prepare the recorded message that a caller hears.

The least effective method is to record the message yourself. Instead, to project the most professional image possible, have someone else record the message for you. If feasible, use someone who is accomplished at speaking clearly and pleasantly to make the recording—an actor, for example.

Use more than one recording and design the messages to sound as informative and professional as you can. One message might say, "Thank you for calling John Doe Photography. John is shooting on location today but will return your call this afternoon" (or "tomorrow" or "on Monday," as applicable). Another might say that you will be back soon or that you can be reached at another number. The idea is to give any potential client who might call enough information to know when you will be available and to assure your current clients that when they need to reach you, they can. You can impress the client with your dependability by returning the calls promptly as promised.

One word of caution: If your office is located in a neighborhood or building that is especially vulnerable to burglary, you should be cautious about revealing how long you will be absent. In such circumstances an answering service would be preferable.

BUSINESS STATIONERY

Except for the telephone, the medium by which the greatest number of people will form an impression about you and your business will be your stationery, which includes your letterhead, envelopes, business cards, invoices, and monthly statements. By taking care to choose and design tasteful stationery, you will immediately set yourself a notch—perhaps a few notches—above your competition.

Inevitably, inexpensive stationery looks cheap. You must remember that the art directors with whom you will be dealing are artistically sophisticated and will immediately form an opinion about your aesthetic sensibilities from your stationery. Therefore, you should studiously avoid using the black engraved lettering on standard white bond paper that fairly screams "low-budget" to anyone who has been in business for any length of time.

Instead, design an attractive letterhead and have it printed on good-quality, tinted paper. The task is not as difficult as you might imagine.

First, go to a local printer and ask to see samples of Strathmore Writing Bristol or the equivalent (he or she will know what you mean). These are papers with laid finishes (paper watermarked with fine lines running across the grain) that have a slight texture and look very sophisticated. Select a color you like.

Next, ask the printer to show you Pantone ink colors (avoid using the standard "process" inks that printers routinely use). Although Pantone inks are more expensive, they will further enhance the appearance of your paper. If you do not trust your taste in selecting a contrasting ink color, simply choose a darker shade of the same color as your paper.

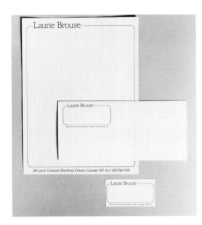

Name: *42 Point Bramley Light, upper & lowercase.* **Address:** *16 point Folio Light, upper & lowercase.*

Well-designed stationery projects an image of substance and good taste.

Follow the procedures described in the text for constructing a "mechanical" that a printer can use to produce your stationery. Shown in the photographs on these two pages are three examples of different print designs. In case you wish to copy one of the styles for your stationery, underneath each photograph you will find the specifications of the type used. You will need to buy a sheet of Letraset® press type for each of the different typefaces you use.

Note that in all three cases we used Folio Light for the address. Regardless of the typeface you choose for your name, Folio Light will probably complement it well.

If you wish, you can add the word "Photography" or "Photographer" below your name, but avoid using a logo unless you obtain professional design advice.

Now that you have in mind the paper and ink you will be using, you need to design your letterhead. If you have a friend who is an artist, he or she might be willing to help you. You do not need a "logo": a clever symbol to represent your business. All you really need is the name, address, and phone number of your business set in an attractive typeface. Although the printer will have some typefaces on hand and will set type for you for a fee, you will find a better selection by going to an art supply store.

At the art supply store, ask to see the Letraset type book. Look through it for a typeface you like—any "serif" or "sans serif" type will be acceptable. (Do not select any of the "decorative" typefaces unless you are confident in your abilities as a designer.)

Once you have selected the type, decide upon a size, and buy a sheet of Letraset press type. Press type is identical in appearance to the type you would purchase from a professional typesetter, but you can apply the type yourself by pressing each letter in place individually. Study the easy-to-follow instructions for using press type printed in the Letraset book, or even better, purchase the book for $1 so you will have it to refer to.

Back in your office, your goal is to produce a letterhead that is interesting but not flamboyant. You must guard against appearing too way out or cute or foolish. But that is easy if you simply remember that tricky designs almost always imply newness. Established businesses have no need to show off. What you want is a design that is clean and simple but sophisticated.

Follow the instructions exactly as you press the type into place precisely as you want it to appear on your letterhead. The result will be what is called a "mechanical." You will probably need to make a separate mechanical for your envelopes, business cards, and possibly for your invoices. The printer will use the mechanicals to run off your stationery. The cost will vary from printer to printer and in different parts of the country, but you can expect to pay between $100 and $150 for 500 copies of each. Be sure to order blank sheets of the same paper; you will need the letterhead only for the first page of each letter you write.

Invoices • Whenever you finish an assignment, you will need to submit an invoice to your client in order to be paid. In the beginning you can simply type your invoices on your letterhead stationery, or to present a more substantial appearance, you can have forms printed up. Most printers have stock invoice forms on which they can print your name, but these forms often do not lend themselves well to the specialized needs of a photographer. If you design your own form using a typewriter, the printer will help you decide on a typeface to use and set the type for you. The paper you use need not be anything special—standard bond will do. The information to be included on the form is indicated on page 57.

Statements • At the beginning of each month, you will have to send a monthly statement to each client who owes you money. Any printer will have standard statement forms on which your name and address can be imprinted.

Shown on this page are some sample letterheads, envelopes, invoice forms, and business cards similar to the ones you might design for yourself. We have indicated the typeface specifications in case you wish to merely imitate one of these designs for your own stationery, rather than work on the designs yourself.

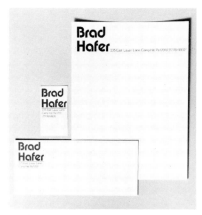

Name: 72 point Pump Medium. *(With this typeface you will need to buy a separate sheet of type for upper and lowercase letters, respectively.) Address: 16 point Folio Light, upper & lowercase.*

THE LEGAL FORM OF YOUR BUSINESS

One of the early decisions you must make is the legal form that your business is going to assume. Of the four possible types—sole proprietorship, partnership, subchapter S corporation, and regular corporation—each has advantages and disadvantages.

Sole proprietorship • The simplest form of business you can choose is the *sole proprietorship* in which you alone are the owner. Startup procedures are minimal, and accounting and tax reporting procedures are relatively simple.

Partnerships • Somewhat more complex are *partnerships* in which you share ownership with at least one other person. The greatest potential problem with partnerships is personality clashes. Usually at some point

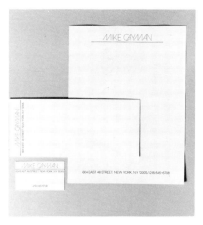

Name: 36 point Avante Garde, Extra Light. *Address:* 16 point Folio Light, uppercase only. *Line:* ½ point rule *(available from Letraset ®).*

a stage is reached where one or the other partner feels he or she is bearing an inequitable share of the workload. In assignment photography, partnerships are almost nonexistent.

Corporations • Corporations, both regular and "subchapter S" corporations are distinguished from the other business forms by the principle of "limited liability." Corporations are regarded as separate legal entities. When you invest money in a corporation, as long as you behave legally, you cannot lose more than your investment. (However, in many business arrangements a small corporation may enter into, the other party will insist that the owners of the firm back up corporate commitments with personal guarantees.) With sole proprietorships and partnerships, debts of the company are also regarded as your personal debts.

Establishing a corporation requires that you file various forms at both the state and federal levels and follow various procedures before you can start operating your business. Any lawyer can incorporate you, or you can do it yourself by following the instructions in *How to Form Your Own Corporation without a Lawyer for Under $50* by Ted Nicholas (Enterprise Publishing Co., 1300 Market Street, Wilmington, Delaware 19810).

Consider hiring an accountant • Each form of business has certain tax advantages and disadvantages. Accountants (and tax attorneys) are best qualified to advise you on the best course fo follow, and we highly recommend that if you have the money, you engage a qualified accountant—preferably one with experience in photography businesses—to help you make initial accounting decisions and to set up a bookkeeping system. However, recognizing that many professional photographers cannot at first afford an accountant, we are going to proceed under the assumption that you will make the form of business decision on your own and engage an accountant after your business is running.

Comparison of business forms • The chart on page 41 summarizes the four possible business structures. The meanings of some of the headings are self-evident; however, some of the headings deserve further explanation.

Comparison of the Four Types of Business Structures

	Sole Proprietorship	Partnership	Subchapter S Corporation	Corporation
Startup costs	Minimal		Relatively high	
Yearly taxes	No annual minimums			Annual minimums at state and sometimes local levels
Tax rate on profits	Individual			Corporate
Loss carryback	Pass to individual	None at the business level, but proportionately available at individual level, depending on circumstances		3 years
Loss carryforward				15 years
Personal loss limitation	Loss limited to amount invested		Loss limited to value of stock, plus any loans made to the corporation	
Social Security payroll taxes	Payable by individuals at 8.1%		Payable by both corporation and individuals at 6.65% each	
Workmen's Compensation	Only employees are eligible	Available	Mandatory for officers	
Group coverage for health, accident, and life insurance	Not deductible		Deductible for corporation and not taxable as income to employees, as long as coverage is less than $50,000	
Retirement plan eligibility	IRA and/or Keogh Plan both as individuals and through the business		—IRA as individuals —Corporate IRAs —Corporate pension plans —Employee profit-sharing plans	
Unemployment Compensation tax payments	Only employees are eligible		Mandatory	
Disability insurance for employee/owner/operators	Optional		Mandatory	
Dividends received	N/A		Generally, 85% deductible by corporation	
Investment tax credits	Pass to individual		Stay within corporation	
Tax-free death benefit	None		$5,000	
Deferred compensation plans	Not eligible		Permissible	

Yearly Taxes—For corporations minimum federal, state, and, in some localities, city taxes are assessed each year, even if the business shows no profit.

Profits Taxed—In all but regular corporations, profits and losses pass directly to the proprietor, partners, or stockholders at the end of each year, and each reports his or her proportionate share on each personal income tax return. In a regular corporation, the profits stay within the corporation, and the stockholders pay taxes only on money they actually receive in the form of salaries, dividends, and other types of compensation.

Loss Carry-back and Loss Carry-forward—This heading refers to whether business losses can be applied to past and/or future tax years.

Dividend Payments—A regular corporation has two primary means of distributing money to its officers and stockholders: through salaries and through dividends. Dividends are a distribution of corporate earnings and profits. Other methods of compensating employees, such as tax-free benefit plans, can also be used if they are properly structured.

Investment Tax Credits—When you purchase an item of equipment that contributes to your business's ability to produce a product or service and that has a useful life of at least three years, the government allows a 10 percent "investment tax credit." This credit is deducted directly from any taxes you owe as an individual, except in the case of a regular corporation. Regular corporations can only use the credit to offset corporate taxes.

Deferred Compensation Plans—Deferred compensation plans refer to programs designed to delay the payment of part of an officer's salary until after retirement, when presumably his or her income and therefore individual tax rate will be lower.

OTHER PRELIMINARY PROCEDURES

Establish a location for your business • You can work out of your home or you can rent an office or even a studio. Your decision will be dictated by what you can

afford and the type of photography that you want to do. Least expensive is to work out of your home, but with such an arrangement you will find it difficult to maintain your business image. However, if you are a photojournalist, there is little reason to maintain a separate office, as long as you can set up a darkroom in your house or in your apartment.

Naturally, the more conveniently you locate your business to your potential clients, the more assignments you will be likely to win. Usually, the larger the city and the more accessible you are in it, the greater the number of potential clients. However, unless you live in a major city, you will probably need to attract clients from an entire region if you are to support a profitable business.

Register at the County Clerk's Office • This will notify authorities that you are operating a business.

Contact the local Better Business Bureau and Chamber of Commerce • When you inform these organizations of your presence, they will know who you are, should they receive any inquiries about you.

File for an Employer's Identification Number • Even if you do not have any employees, you need the number to open a bank account and to file tax forms.

Check with your local sales tax bureau • Every locality has its own sales tax collection rules and regulations to which you must conform. The local sales tax bureau will tell you when you must collect sales taxes and will sometimes issue you a sales tax collection number. Be sure to follow their instructions carefully.

In most localities you will not have to collect sales taxes unless you are selling a product to its final consumer. When you take a photograph on assignment, you are actually only selling the image, not the photograph itself, and that image will be used again by someone else before it reaches the ultimate consumer. Therefore, usually you will not be responsible for collecting sales taxes.

Arrange for insurance • Insurance is one of those expenses that you hate to incur but you cannot afford to ignore. Be careful, however, not to purchase more insurance than you really need.

The only way to purchase insurance is through an agent, whose commission will be based on how much

coverage he or she can convince you that you need. These are decisions you must make by yourself, based upon your own particular circumstances and, in some localities, upon legal requirements.

Try to obtain references from friends about the insurance agents in your area. Some agents realize that their long-term interests are better served by giving you good advice than by overwhelming you with insurance coverage that you do not need and cannot afford. Unfortunately, for every conscientious agent there are many more with fewer scruples.

The types of insurance you should at least consider include general business liability (especially if you use models), multiperil, fire and theft, health, and disability. If you are in a partnership or corporation, you can also look into life insurance that would be used to buy out your interest in the business from your survivors should you die. (This is a common business practice designed to prevent an inexperienced person from acquiring authority in a company by virtue of an inheritance).

YOUR CREDIT RATING AND CREDIT LINE

Imagine yourself shooting an assignment on location, in the Bahamas, for example. A $1,500-per-day model, the art director, miscellaneous other people are there and you have just discovered that all of your camera equipment has been stolen. What do you do?

In such a situation, it is usually cheaper to buy new equipment than to cancel the shooting. However, unless you have a credit line that allows you access to the cash you need, you can do nothing. With a credit line (that is, by having immediate access to borrowed cash without being required to undergo a credit check) you can replace your equipment and save the shooting.

As a businessperson, your ability to obtain credit is a direct measure of the way outsiders view your personal reliability and that of your business. Do not wait to develop your credit rating, and never underestimate the value of maintaining an exemplary credit profile.

Establish a credit history • The first step in acquiring a credit rating is to establish a credit history. One method is to go to a bank and borrow money, using your passbook savings account as collateral. You do not need a credit history to obtain that type of loan. By scrupulously paying your bills on time, you build a favorable credit rating. Another method is to approach small stores that know you and ask them to allow you to open charge accounts. For instance, the store at which you purchase film will probably allow you to charge once the proprietor knows you, and local department stores may be willing also. If no stores will agree to open an account, some may allow you to advance them a sum of money that you can draw against. Eventually, they will allow you to switch to a regular charge account. Again, your payment record becomes part of your credit history, and after a few months you can use these stores as credit references for opening additional charge accounts elsewhere.

Your business bank account also forms part of your credit profile. If at all possible, try to maintain a balance of at least $1,000 at all times, and be very careful not to bounce any checks.

Credit cards • As soon as you can, apply for credit cards. You will need to be able to show an income of at least $12,000 per year and give three credit references, including your bank. If possible, apply for credit cards while you are working for someone as a salaried employee; credit card companies hesitate to give credit to people who are newly self-employed.

Bank credit cards (for example, Master Card® and Visa®) are important because they automatically provide you with a line of credit. To obtain cash, you need only go to a bank and sign for as much cash as you need, up to your credit limit.

So-called entertainment credit cards (for example American Express and Diner's Club) charge higher fees, but are more prestigious than bank credit cards. More important, there is no specific limit on the amount you can charge, although you will not be permitted to charge unusually expensive items without first obtaining clearance. The big advantage of the entertainment cards is

their higher limits on the amount of cash you can draw in an emergency.

Credit cards may be issued in the name of a business, but you will be required to accept liability personally for any charges the company does not pay. Thus, bank and entertainment cards reflect more your personal credit rating than that of your business.

Once you have one or more credit cards, charge as much as you can, but be sure to pay your bills promptly. With the bank cards, at first your credit limit will be relatively low, so apply every six to twelve months for a higher credit limit. Eventually your limit will be high enough to cover your cash needs in most eventualities.

Always be careful, of course, not to abuse your credit or overextend yourself. Your purpose is to build a credit rating, not to fall into bankruptcy by depending on borrowed money to meet routine expenses. Each time you charge something, be sure that the money to cover the charge will be available when the bill arrives. Credit is a necessity in assignment photography. Properly managed, credit is also a blessing, but mismanaged, credit becomes a curse.

PERSONAL REPRESENTATIVES ("REPS")

Many established photographers engage personal representatives ("reps") to solicit assignments. In a sense, if you engage a rep, he or she becomes your business partner.

What a rep does • A rep does everything necessary to obtain work for you. In particular, he or she advises you on your portfolio and then shows your portfolio to prospective clients. Usually, a successful rep will already have existing accounts that will bring you work as soon as he takes you on. Some reps also handle a photographer's financial accounts, but from your point of view, it is better that you pay him, rather than he pays you.

What you pay your rep • In exchange for his or her efforts, your rep will be entitled to 25 percent of the

fees you receive for local assignments and 30 percent of the fees for out-of-town work. This fee structure applies even to clients you already had at the time you and the rep started to work together.

Do you need a rep? • You only need a rep if you have so much work that you yourself do not have the time to take your portfolio around to art directors. Most photographers do not enjoy the process of soliciting work and are pleased by the idea of someone else doing the legwork, but meeting with art directors is a part of the learning experience that you should not miss, at least at the beginning of your career.

Also, you should only engage a rep if you are convinced that the additional fees he will enable you to bring in will more than compensate for his percentage.

How to get a rep • Obtaining an experienced rep is not easy. No established rep will take you on unless you already have a good record and are well-established. In addition, a rep will expect you to already have a substantial income.

The best reps are members of the Society of Photographers' and Artists' Representatives (SPAR). A list of SPAR members is available from the society (Address: 514 East 83rd Street, New York, NY 10028), but do not contact these members until your business is very successful.

An alternative is to work with an inexperienced rep. The problem here is twofold: the rep probably knows even less about the business than you do, and you must blindly trust that he or she is representing you well. The wrong person acting as your rep could do your business more harm than good.

In summary, as a beginner in professional assignment photography, you would probably be better off without a rep than with one. Pay your dues by learning to find your own work. When you know all there is to learn about attracting work and you have established such a large clientele that you no longer have time to find clients on your own, then is the time to consider engaging a personal representative to remove that burden from your shoulders. ■

BOOKS & ACCOUNTS*

4

Bookkeeping is the process of maintaining records of all the financial transactions of a business. Accounting is the process of correlating and summarizing the results of bookkeeping into forms that are useful in measuring the business's performance.

A second, but extremely important, purpose for maintaining books of account is to provide the information necessary to determine the tax liabilities incurred by the business and its owners.

To learn the fine points of bookkeeping and accounting you really need formal training. What we are going to do here is help you set up an elementary set of books and show you how to enter transactions. By starting out properly, when the time comes that you can afford to hire a bookkeeper or accountant to help you, you will be able to provide them with the data they will need to work with.

We cannot overemphasize the importance of maintaining accurate records from the very first day of your business. Many people fall prey to the common misconception that in the early stages a small business can get along with an informal bookkeeping system. Too late does it become apparent that informal records are inaccurate, and trying to reconstruct the financial history of a company based on such records is nearly impossible.

Many new businesses that fail do so for one or more of three reasons: the owners lack skill or experience, the business is undercapitalized, or the business is managed poorly and does not maintain adequate business records. This discussion will help you avoid the last mistake.

PRELIMINARIES

Record-keeping discipline • The foundation of a good bookkeeping system is discipline. Without fail you

*This chapter was prepared with the help of Edward D. Heben, an independent accountant in public practice, residing in Mount Vernon, New York. Heben has a number of Manhattan-based assignment photographers as clients.

must discipline yourself to maintain on file all bills, receipts, cancelled checks, and bank statements for future reference. In addition, you must be careful to record—in a timely manner and in the appropriate books—a record of every single financial transaction your business incurs.

The tax year • Having decided upon the form of your business, you must then decide on a tax year. For sole proprietorships and partnerships, the tax year must coincide with the calendar year. For corporations, the tax year can end on the last day of any month within the first 12 months after the corporation is formed.

Depreciation • To avoid conflicts with tax authorities, one concept you should understand, if you do not already, is that of depreciation. If you buy an item of equipment for your business that has a useful life of one year or less, you are permitted to "expense" the item; that is, you can deduct the full value of the item on your next tax return. However, if the item has a useful life of more than one year—a camera, for example—you must "depreciate" the item; that is, you must spread deductions for the value of the item over a period of years.

As of January 1, 1981, a new system called the "Accelerated Cost Recovery System" (ACRS) went into effect. Under the ACRS an asset is depreciated over a period of 3, 5, 10, or 15 years, depending on the category into which the asset falls. Consult Internal Revenue Service publications for a detailed explanation of how the ACRS applies to your business.

Accounting method • You have the option of choosing between cash and accrual accounting. Cash-basis accounting means that all receipts and disbursements (money paid out) are recorded on your books as of the date the money is actually received or disbursed. Accrual-basis accounting means that you record receipts and disbursements as they are billed. You will find it easiest to maintain accounts on a cash basis. When you hire an accountant, he or she may suggest that you change to the accrual method.

Books of account • As transactions occur, you will need to record them in appropriate journals. As a bare minimum you will need two: one as a cash receipts

journal, in which you will record all money received by you, and one as a cash disbursements journal, in which you will record all money you pay out. Another useful, but not strictly necessary, journal to maintain is an accounts receivable journal. As your business prospers and you can afford regular accounting advice, you may also want to initiate sales, purchase, petty cash, and payroll journals.

The journals will constitute a log of your business activity. By adding up the entries in your journals at the end of each month and again at the end of the fiscal year, you will have monthly and yearly summaries of the progress your business is making.

Double-entry bookkeeping • The only acceptable method of maintaining books of account is through double-entry bookkeeping. Single-entry methods are not sufficiently accurate to satisfy either your needs as the manager of a business or the needs of governmental authorities.

The principle behind double-entry bookkeeping is that for every debit entry you make, you also make a corresponding credit entry in the appropriate account. At all times, your sum of debit entries should equal the sum of credit entries; if not, you have made a mistake.

Just as important, double-entry bookkeeping enables you to organize your business transactions into categories that you will find useful later as you monitor the health of your business.

THE CHART OF ACCOUNTS

Before you can set up your books, you need to draw up a "chart of accounts," a listing of the accounts your system will use. The idea is to choose account categories that will give you valuable information as your business progresses.

The sample shown is typical of a chart of accounts for an assignment photography business. You can copy it exactly for your own use or modify it to better meet your needs. Any income or disbursement that does not fit into a specific account is entered into an account labeled "miscellaneous." If you have set up your chart of accounts

BALANCE SHEET ACCOUNTS

CURRENT ASSETS

Acct
#

101	Cash on Hand
103	Cash in Bank—Regular Checking
105	Cash in Bank—Special
107	Cash in Bank—Savings
110	Investments—Current
120	Accounts Receivable
121	Allowance for Uncollectibles
131	Inventory (film, paper, chemicals, frames, mats, etc.)
133	Unexpired Insurance

LONG-LIVED ASSETS

151	Land
155	Buildings
156	Accumulated Depreciation—Buildings
157	Studio and Photographic Equipment (cameras, lights, etc.)
158	Accumulated Depreciation—Studio and Photographic Equipment
159	Furniture, Fixtures, Office Equipment
160	Accumulated Depreciation—Furniture, Fixtures, Office Equipment
161	Transportation Equipment
162	Accumulated Depreciation—Transportation Equipment
171	Leasehold Improvements
172	Accumulated Amortization—Leasehold Improvements

OTHER ASSETS

181	Organization Costs
182	Accumulated Amortization—Organization Costs
191	Security Deposits

CURRENT LIABILITIES

201	Accounts Payable and/or Accruals
203	Notes Payable—Due within One Year
205	Payroll Taxes Payable—Social Security
206	Payroll Taxes Payable—Federal Withholding
207	Payroll Taxes Payable—State Withholding
208	Payroll Taxes Payable—Local Withholding
209	Payroll Taxes Payable—Disability Payable
210	Payroll Taxes Payable—State Unemployment Payable
211	Payroll Taxes Payable—Federal Unemployment Payable
220	Sales Tax Payable
225	Commercial Rent and Occupancy Taxes Payable

LONG-TERM LIABILITIES

251	Notes Payable—Due after One Year

thoughtfully, you will need to make few entries in the miscellaneous columns. Once you know how many cash accounts and disbursement accounts you will have, you will know how many columns there should be in the journals you buy (from any stationery store).

On these two pages is a chart of accounts you can use. If you are unfamiliar with bookkeeping, you will not be using some of the accounts, but your accountant will use them eventually. At first, the accounts you will be concerned with are the cash accounts, possibly the tax accounts, the income/sales and services accounts, the cost of sales and services accounts, and the operating expenses accounts.

HOW THE SYSTEM WORKS

Prepare the first pages of your cash receipts journal, using the journal pages on p. 54–55 as a model. Copy the column headings exactly. If you have any other regular sources of income, you can add an account to your chart of accounts and label a column with the account name. Any income that does not fit into one of the other column headings is recorded in the miscellaneous column, along with the account number.

Next, prepare the first pages of your cash disbursements journal. Copy the first five and last two column titles of the sample journal exactly. The remaining columns should be headed by the titles of the accounts you use most frequently from the cost of sales and operating expenses accounts listed on the chart of accounts. Any expense that does not fit into one of the other column headings is recorded in the "other" column, along with the account number.

Handling cash receipts • Each time you receive a payment, be it in cash or by check, you fill out a bank deposit slip, note the source of the money on the slip (for example, the number of the invoice a check is paying) and deposit the money in your checking account. In your cash receipts journal, fill in the current date and the source of the check or cash, and enter the amount in column 2, cash amount. You then debit the cash in bank account by filling in the amount of the deposit in col-

umn 3 and credit whichever is the appropriate income account by writing the amount in the appropriate column. You follow the same procedure for each payment you receive during a month, being sure to always make an entry in the cash amount account and make a corresponding entry in the appropriate income account. (Should a given check ever include payments that should be split into more than one income account, do so, but be certain that the total of the income amounts equals the amount of the cash amount account entry.)

Handling cash disbursements • The procedure for making entries in your cash disbursements journal is similar. For every check you write and for every charge the bank makes, enter the date, to whom you paid the money, the check number (or "DM" for "debit memo," if no check was written), and fill in the cash amount column. Then enter the amount of the payment in the expense account(s) that applies.

Bank reconciliations • Each time you receive a bank statement you should check it to make certain that the bank has made no errors. The statement itself will explain the procedures to follow. In addition, at the end of each month you should execute a bank reconciliation, which verifies that the bank statement and your books are in agreement.

The first step in a bank reconciliation is to total all the cash in bank columns in both your journals. Then, use the column totals, your bank statement, and the information you have written on your check stubs to fill in the blanks on the bank reconciliation form shown on page 57. If a discrepancy exists, you must check all your back entries until you find where you made a mistake.

Monthly summaries • In addition to doing a bank reconciliation, at the end of a month you should prepare monthly summaries of all the accounts. Add up all the columns in each journal. Within each journal if the cash in bank column equals the combined sum of all the columns to the right in the journal, then the journal is in balance. Moreover, the total of each column tells you exactly how much you received or spent during the month in each of the account categories.

OTHER LIABILITIES

271	Customer Deposits Payable (Advance Collections)
273	Loans & Exchanges

CAPITAL

300	Sole Proprietorship, Partnership, or Corporate Equity Accounts to Be Utilized as Applicable

INCOME/SALES AND SERVICES

401	Commercial Assignments
403	Stock Sales
405	Reimbursements

COST OF SALES AND SERVICES

501	Film and Processing
503	Assistants' Fees
505	Darkroom Supplies
507	Production Costs

(The above category should include any items that contribute directly to producing your product or generating income. General expenses, those that can be thought of as being overhead, are considered "operating expenses" and are listed below.)

OPERATING EXPENSES

601	Salaries and Wages
603	Payroll Taxes—Social Security
604	Payroll Taxes—Disability Insurance
605	Payroll Taxes—State Unemployment Insurance
606	Payroll Taxes—Federal Unemployment Insurance
607	Payroll Taxes—Local Payroll Taxes
611	Employee Benefits
613	Rent
615	Commercial Rent and Occupancy Tax (if applicable)
617	Utilities
619	Telephone
621	Office Supplies and Expenses
623	Postage and Mailings
625	Advertising and Promotion
627	Legal
629	Accounting
631	Interest Expense
633	Bank Charges
635	Cleaning
637	Repairs and Maintenance
639	Equipment Rentals
641	Dues, Subscriptions, Memberships
643	Messengers, Shipping, and Freight
645	Insurance—General
647	Travel
649	Entertainment
651	Bad Debts
653	Depreciation and Amortization
655	Miscellaneous
657	Taxes—Sundry (as applicable)

Date 1982	Payee	Check #	Cash Amount (CR)	Net Payroll (DR)	Film & Processing (DR)	Assistants' Fees (DR)	Da
Apr 1	Picture Perfect	1211	6050		6050		
2	Bill Marlowe	12	7500			7500	
3	Goliath Insurance	13	75000				
3	Internal Revenue Svce	14	12550				
4	Jane Solomon	15	52381	52381			
4	Bill Johnson	16	140656	140656			
6	Zebra Stationers	17	3862				
8	Picture Perfect	18	8150		2000		
17	Bank Charges	DM	800				
22	Acme Rentals	19	1800				
22	John Curtis	1220	12500				
23	BFD Realty	21	50000				
27	Karbro Lumber	22	7555				
			378804	193037	8050	7500	
			378804				

Date 1982	Source	Invoice #	Cash Amount (DR)	Bank Deposit	Assign-ment Fees (CR)	Stock Sales (CR)
Apr 3	AA Agency	2146	54000	54000	40000	
9	Davis Advertising	2084	40000			40
	Flacl Graphics	2062	124200		100000	
	Zebra Design Assoc.	2151	37500	201700	30000	
17	Goliath Ins. Co.	memo	30000	30000		
24	Midtown Bank	memo	100000	100000		
			385700	385700	170000	40
			385700			

54

otography
ents Journal
82

Production Supplies & Expenses (DR)	Studio Rentals (DR)	Equipment Rentals (DR)	Office Supplies & Expenses (DR)	Taxes Account #	Taxes Amount (DR)	Other Account #	Other Amount (DR)
						645	75000
				603	12550		
			3862				
						633	800
		1800					
	12500					613	50000
7555							
7555	12500	1800	3862		12550		125800

378804

Maintaining Accurate Financial Records

As described in the text, as a minimum you should maintain the two journals shown here.

Cash Disbursements Journal (top)

Record each expenditure during a month. Do not forget to include bank charges as noted on your monthly bank statement. At the end of the month the sum of column 1 should equal the combined sums of columns 2–9, 11, and 13. If not, find and correct the error.

Cash Receipts Journal (bottom)

Record each item of income received during a month. At the end of the month the sum of column 2 should equal the combined sums of columns 4–7 and 9. If not, find and correct the error(s). (Since more than one check may be deposited in the bank at one time, column 3 relates the individual checks to the deposit slip issued by the bank. The sums of columns 3 and 2 should be equal.)

tography
Journal

	Sales Tax Payable (CR)	Other Account	Amount (CR)
0000	4000		
5000	9200		
7500			
		Ins. Rebate	30000
		273	100000
2500	13200		130000

5700

Financial statements • Aside from being required by law, maintaining accurate books of account provides you with the raw material from which various valuable financial statements can be prepared. Unfortunately, these statements require a greater knowledge of accounting than we can detail here. Any good textbook on accounting will teach you what you need to know to prepare the basic statements. However, even if you do not care to teach yourself accounting, by following the procedures outlined above, you will have prepared the data that you or an accountant will need at the end of the year to prepare your tax returns, and in the meantime, you will find the information about each individual account useful for monitoring the progress of your business.

CASH FLOW

An important aspect of running a business is cash flow. Any business must have cash available to meet expenses. Even a very successful business can become insolvent if the money needed to meet current expenses is not available for months.

For example, suppose you are just starting out in your business, but immediately line up a few assignments for substantial fees. If you charge the film that you need to complete the assignments at a local photo store, you will be expected to pay within 30 days. However, you may not receive payment of your assignment fee for 90 days or more. Unless you have cash available within your business to hold you over until your fees come in, your business will be in serious trouble. This type of problem confronts every business every day.

To protect yourself, you should continuously maintain an accurate cash flow projection for approximately six months into the future. All you need to do is determine how much cash you have at the beginning of the current month and then predict as accurately as you can how much money you will actually receive during that month and each of the following five months, as well as how much money you will actually need to pay out. For any month in which your outflow of funds exceeds your inflow of funds, you will have to draw upon your bank

account to make up the difference. If in any month the amount of cash in your bank account will be insufficient to make up the difference, you will need to start well in advance trying to solicit a loan to carry you through until the money you are owed comes in. If you cannot honestly predict that the money will, indeed, eventually be available, your business will be in serious difficulty unless you can take steps to cut down your expenses.

One of the advantages of maintaining a current, accurate set of books is that by studying the various accounts you can often identify areas where you can cut back on unnecessary expenses.

MANAGING ACCOUNTS RECEIVABLE

No matter how talented you are as a photographer, if you expect to receive all the money you are owed, you will have to establish a system for making certain that clients are billed appropriately and that they pay their bills with reasonable promptness.

Job sheets • As you shoot an assignment, you will be incurring expenses, some of which will be billable to your client and some of which will not. At the end of a shooting, you will need to prepare an invoice that accurately reflects your expenses and the amount of your fee.

By preparing a job sheet for each assignment and then entering expenses *as you incur them* on the sheet, you avoid the drudgery and potential inaccuracy of having to try to remember later what your expenses were on each assignment. With the job sheet in hand, you can easily prepare an invoice.

Invoicing • Using either your own stationery or some that you have had printed, prepare a neat invoice. Include on every invoice:
1. The current date.
2. Your invoice number. Each invoice should be numbered consecutively, but for the sake of your early clients, do not start with invoice number "1."
3. The name and address of the client.
4. The name of the art director you worked for.
5. The client's purchase order number. Some

BANK RECONCILIATION

At the end of each month you must reconcile your books and the latest statement you have received from the bank. Follow this procedure:

1. Bank balance at beginning of the month: _____
2. Add: Deposits you made during the month: _____
3. Subtotal (total cash available): _____
4. Deduct: Disbursements (total of checks written during the month): _____
5. Subtotal (equals checkbook balance at the end of the month): _____
6. Add Checks outstanding at the end of month:
 Number _____ Amount _____
 _____ _____
 _____ _____
7. Subtotal (line 5 + all entries on line 6): _____
8. Deduct: Deposits made but not shown on statement: _____
9. Subtotal (line 7 − line 8): _____
10. Balance as per bank statement: _____

If line 7 does not equal line 10, you must locate the source of the error and correct it.

companies contract jobs by issuing formal purchase orders. Usually, if you do not include the purchase order number on your invoice, payment will be significantly delayed.

6. The date you completed the assignment.
7. A brief description of the assignment of sufficient detail to identify it (for example, package photograph for XYZ skin creme).
8. Your fee.
9. An itemized list of billable expenses.
10. The exact usage to which the photograph will be put. As will be explained in Chapter 6, your fees will depend on how the photograph will be used. By defining right on the invoice exactly what your fee covers, you will ensure that, should the photograph be re-used or used in a manner not originally agreed upon, you will be entitled to an additional fee.
11. Any applicable sales taxes.
12. The total amount you are due.
13. The statement "Terms: net 30 days."

Make an original and two carbons. Send one carbon along with the original to the client. Be sure to send the invoice to a specific individual—usually the art director with whom you worked.

File the remaining carbon of the invoice in an invoice book—a looseleaf notebook will do, or you can buy a formal invoice book at a stationery store. In addition, for ease in managing your paid and unpaid invoices, we recommend that you initiate an accounts receivable ledger. (Stationery stores carry ledgers—any simple one will be satisfactory.)

Within the ledger every client is given a separate page. Whenever you send an invoice to a client, you create a ledger page, if one does not already exist for that client, and then enter the date, the invoice number, a description of the shooting (if you want one for later reference), the amount of the invoice, and the overall balance of all unpaid invoices due to you from that client.

When a client pays an invoice, you add the check to the day's bank deposit slip, mark the current date on the

invoice in your invoice book and stamp it "paid." In addition, on the client's ledger sheet you enter the date, the invoice number, and the amount paid and calculate the new balance due.

Monthly statements • Rarely will your invoices be paid in less than thirty days, and usually the period will be much longer. When you are working directly for the ultimate consumer of the photographs, as when you are shooting annual reports for a corporation, you will usually receive payment between thirty and sixty days after you send your invoice. However, when you work for an advertising agency, often you will not be paid until they are first paid by *their* client. This usually adds another thirty to sixty days. Thus, you sometimes will not be paid until many months after a shooting.

By consulting your accounts receivable ledger, you will know immediately to whom you need to send statements. The statements you send need only include the numbers of the outstanding invoices, the amounts of each invoice, and the total amount due. Address the statement to the company rather than the individual person with whom you worked. If the firm is large, send the statement to Accounts Payable.

COLLECTING DELINQUENT ACCOUNTS

When you agree to take on an assignment, in essence you are also agreeing to open a charge account for the person or company that gives you the assignment. Most of your clients will eventually pay their invoices merely on the basis of your monthly statements, but some will require that you take additional action.

Phone calls • As soon as you believe that an account is seriously delinquent (but not fewer than ninety days from the invoice date), call the person for whom you performed the assignment and tactfully try to obtain an explanation for the delay. Frequently you will be told that they are still awaiting payment from their client.

If the explanation you are given is unacceptable, however, try to pin down the person on when you can expect payment. Keep accurate notes of each phone call and what you were promised.

You must exercise judgment as to how hard to press. Some clients really do plan to pay; others will string you along forever. There is always the danger that if you press too hard, you will lose the client, but there is also the danger that if you do not press hard enough, you will not ever be paid. Judgment comes through experience and a sixth sense that develops over time.

Collection agencies • If a client has failed to pay despite repeated phone calls and you are convinced that he never will and that you never want to work with him again, anyway, you can go to a collection agency. Reputable agencies will keep approximately 25 percent of what they collect.

Some collection agencies are respectable, some are not. Your accountant may be able to recommend an agency, or you can look in the Yellow Pages. Make sure the agency is bonded, and look for membership in the Commercial Law League of America.

Small Claims Court • Most jurisdictions have Small Claims Courts specifically intended to make the process of resolving small disputes as painless as possible. The limits you can sue for in Small Claims Court vary, but $1,000 is not uncommon. If your case meets the legal requirement within your area, Small Claims Court provides a relatively convenient means for collecting delinquent accounts. All you need to do is contact the court, and you will be sent instructions and the forms you need to file. Small Claims Court suits are time consuming, but usually effective.

TAXES

You are potentially liable for paying income taxes, sales taxes, payroll taxes, commercial occupancy taxes, and any other taxes your locality requires. As soon as you notify the authorities that you are in business, either by registering with them or by filing your first tax forms, you will be inundated with forms and instruction manuals. Here again, an accountant is invaluable, but if you have no choice, you can wade through the manuals and figure out your tax obligations yourself.

As a businessperson and eventually as an employer, you become an agent of the tax collection bureau. Always remember that any sales or payroll taxes you collect are not yours, but belong to the government. There is no surer way to find yourself in trouble than to fail to pay your taxes on time—or worse, to spend the money and not pay them at all.

Depending on the amount of money you collect, you may have to make tax payments monthly or even weekly. Read carefully all the information you receive, and conform scrupulously to the payment schedules and requirements as indicated.

MANAGING EXPENSES

If you meet all your expenses by paying cash at the time of purchase, keeping track of expenses will require nothing more than that you save all receipts and maintain an accurate cash disbursements journal. If you have charge accounts, however, you will need a system to organize your bills so that you pay them when due.

Establish an unpaid bills file, in which you can organize your bills by the date they are due to be paid. Since you are trying to build a good credit rating, be sure to allow enough time for checks to pass through the mails, and take advantage of any discounts offered for prompt payment.

When you pay a bill, stamp it "paid," add the date, and write in the number of the check you wrote. File these in a separate paid bills file arranged alphabetically and chronologically. At the end of each fiscal year retire the old paid bills file and start a new one. Save the retired file for at least three years.

Of course, the transaction will also be recorded in your cash disbursements journal.

Managing your business is a continuing task that you avoid at your peril. However, by expending the effort to run your business conscientiously, in the long run the return you derive from your efforts will be substantial. ■

PORTFOLIOS & PROMOTION

5

In pursuing assignments to shoot you will find that nothing is more important than your portfolio: the collection of photographs you show potential clients. With the right portfolio—one that shows off your talents in a manner that will make an indelible impression on art directors—you will be judged upon your photographic abilities. With the wrong portfolio, no matter how talented you are, you and your work will rarely be given a second thought. Clearly, no single factor in promoting yourself will have a greater effect on the amount of work you obtain than your portfolio.

WHAT A PORTFOLIO DOES

Your portfolio is more than simply a sample of your work, it is also your professional calling card, displayed for all the world to see. When you show your portfolio to an art director, it performs a variety of important functions.

Your portfolio shows that you have technical ability • Because an art director assumes that when you label yourself a "professional" you are technically proficient, he or she will not be looking at your work specifically to assess your technical abilities. However, he will immediately notice any technical flaws that are present, and his opinion of you as a professional will be influenced greatly by them.

Your portfolio shows that you know how to take a particular type of shot • For example, if an art director is looking for someone to photograph clothing, he needs to know that you understand the fine points of clothes photography (such as always being aware of the presence of wrinkles). Your portfolio assures him that you are familiar with the particular specialty in which he is interested.

Your portfolio shows that you can organize and execute a shooting • Part of an art director's job is to select the best person to provide the photographs for a project. If you fail, so does he or she. Therefore, one of the main purposes of your portfolio is to give an art director confidence in your skills.

Moreover, some art directors are not especially confident in their own abilities. A savvy art director knows that a talented photographer will take complete charge and can carry out a shooting on his own.

Therefore, your portfolio—as well as all other aspects of your presentation and demeanor—should be designed to convince an art director that if he gives you an assignment, his worries are over.

Your portfolio shows that you are worth your fee • If your business is to be successful, you will need to keep your fees as high as the traffic will bear. By maintaining a strong portfolio, you will be able to charge higher fees than an amateurish portfolio can command. By presenting your work carefully and treating all your photographs with respect, you say to the art director: "Look how valuable my photographs are." That makes it easier for him or her to justify paying you your fee.

Your portfolio shows that you have the style the art director is looking for • Before an art director seeks photographers to shoot a particular project, he conceives in his mind a design for the ad (or whatever he is working on) and commits it to paper. When he looks at photographers' portfolios or tries to remember those he has been shown in the past, he is searching for a photographer whose visual style supports the ad's concept and design. Your portfolio presents your style of photography and allows him to decide if it is compatible with the design of his ad.

THE SECRET OF A WINNING PORTFOLIO: MAKING AN INDELIBLE IMPRESSION

Art directors look at so many photographers' portfolios that very quickly all but a few blend into a vague, forgettable mass. The challenge you must meet in pre-

In preparing a portfolio for assignment work, include photographs that are as "commercial" as possible.

Both of the photographs of a rose shown here demonstrate that the photographer is talented, but the photograph at right is far more likely to stimulate commercial assignments than the one below. An art director looking at the photograph at right knows at once that the photographer understands the needs of the commercial marketplace. In addition, including the silverware shows that the photographer knows how to light a difficult subject.

As the photograph at right demonstrates, commercialism does not imply that the work must be crass. Instead, being commercial means that you should recognize that your talents will be engaged for the purpose of selling products. The easier you make it for an art director to visualize his or her product and your photographs together, the more likely you will be to win assignments.

(Photo Credit: Michael Stuckey)

65

"Style" in photography can be a difficult concept to grasp, but having a portfolio that demonstrates a consistent style can be valuable in attracting the attention of art directors to your work.

Below, the nail polish bottle is photographed competently, but unimaginatively. The photograph has no technical flaws, but the treatment shows no particular photographic style.

As you become more experienced at photography, you will find that all your photographs begin to acquire common characteristics, regardless of subject. You should study your photographs and actively seek to nurture a distinctive style of photography. In the early stages of your career you will be able to find work even without having a distinct style, but eventually style will become critical if you are to win the really high-paying assignments.

paring your portfolio is to make it so outstanding that it leaves a lasting mark in the art director's mind.

The importance of style • Art directors cannot possibly remember every photograph they see, nor are they likely to remember even a single photograph from each portfolio they are shown. Why is it, then, that some photographers receive calls months after they have shown their portfolios, while other photographers never hear another word? The explanation is style.

Style is an elusive but critically important concept. It refers to those aspects of a photographer's work that stamp it as uniquely his or her own. Perhaps the clearest example of the presence of a recognizable style can be found in the paintings of Pablo Picasso. Even a person possessing only a passing acquaintance with art can immediately recognize a painting that came from Picasso's hand; his style was so strong and well defined that it shines through every painting he ever made.

Their style distinguishes the top photographers from all others. A clearly defined style is less important in small cities, but in the larger cities, where competition is heavy, style is paramount.

When an art director studies your portfolio, your style—if and only if it is readily apparent—makes the greatest impression. All else is likely to be lost. No matter how stunning the individual photographs you have assembled, if they do not reflect a uniform style, chances are that you and your portfolio will be forgotten as soon as you leave the room.

Because style only comes with experience, you cannot expect to develop yours immediately. However, as you assemble your portfolio, you should be looking for photographs that reflect a uniform style as closely as possible. Otherwise, the impression your portfolio leaves will be severely diluted. When you are first starting out and you are shooting only for small accounts, style need receive far less emphasis than later in your career when you are striving to attract prestigious clients.

THE "COMMERCIAL" LOOK

Your portfolio must appeal to people who need photographs for use in promoting commercial products. Some

The three photographs shown here are of products similar to the nail polish on the facing page, yet each is treated in a very different photographic style.

At left, above, a bold, graphic, almost surreal style is clearly apparent. Note how small the bottle is within the frame.

At right, above, the tones are more subdued and the overall style more casual. The camera angle is head-on, the bottle looms relatively large, and the photograph has a realistic feeling overall.

At left, below, is a highly stylized studio treatment. Color is minimal, but the effect is one of extreme sophistication.

Any one of these three photographs would be fine in a portfolio, although placing all three together in the same portfolio would be a mistake. The foundation of a strong portfolio is not just that each photograph is excellent, but that each displays a strong and consistent photographic style.

Often, a particular photographer will be given an assignment simply because by looking at his or her portfolio, the art director could visualize in advance what the final photograph would look like.

If the three photographs above were in the same portfolio, an art director would not know whether the photographer would be likely to shoot multiple images, close-ups, or distance shots.

In the series at right of the same three subjects, the treatment in each case is similar. This is the type of stylistic consistency that results in memorable, job-winning portfolios.

subjects and treatments are more commercial than others. For example, a photograph of a rock, no matter how skillfully executed, will probably have less commercial appeal than a photograph of an orange, even if the orange and the rock are treated identically in the two photographs. Likewise, an orange that is photographed unimaginatively will have less commercial appeal than the same orange photographed in a way that makes it look succulent. As you might imagine, the more commercial the photographs in your portfolio, the easier it will be for an art director to be able to visualize your photographs of his project and the more confidence he will have in your ability to make his product look appealing to potential customers.

ASSEMBLING YOUR FIRST PORTFOLIO

When you show your portfolio to an art director, you are trying to convince him that he can use your talents. Therefore, in producing and selecting portfolio photographs, always keep in mind that you want to make it as easy as possible for the art director to visualize your photo with his ad. When you are successful, you will strike a responsive cord and stimulate in him the desire to use your photographs.

Obtaining photographs • You have two sources of photographs for your portfolio: the collection of photographs you have taken over the years and photographs you take specifically for inclusion in the portfolio.

There is nothing wrong with drawing on some of the photographs you have taken over the years, although chances are they will not be especially commercial. Some photographers have a natural tendency to produce images that lend themselves well to commercial usages; perhaps you are one of them. If not, then you should probably spend the time necessary to produce commercial images specifically for your portfolio by giving yourself a series of self-assignments.

Commercial self-assignments • One way to start yourself thinking in terms of the commercial market is to give yourself self-assignments. The idea is to pretend

TOM GRILL

that you have been given an actual assignment by an art director and then take the photograph while acting as your own art director. The resulting photographs will teach you to think commercially and at the same time provide you with material to use in your portfolio.

Start an assignment by searching through magazines until you find an advertisement that you like but that you think you can improve upon. Look for photographs that reflect a style similar to yours and that are of subject matter appropriate to the field of photography you expect to work in.

Once you have made your selection, produce three photographs based upon the advertisement. In your first attempt try only to duplicate the photo in the ad. Shoot as much film as you need to be sure you have the shot. In your second and third attempts design your own ad. Both images should support the theme of the ad and illustrate its headline, but otherwise the photographs should be entirely your own. The best photographs of the series will become part of your portfolio.

Self-assignments can be surprisingly difficult to complete, but you will find the exercises invaluable. Even when you are merely trying to duplicate a photograph, you will encounter many unexpected problems and experience some of the obstacles assignment photographers must routinely overcome. When you must also originate the idea of the photograph yourself, the challenge will be even greater.

Continue giving yourself self-assignments until you have at least twenty-five high-quality commercial images from which to select a portfolio.

Selecting portfolio photographs • Once you think you have enough material to prepare a portfolio, assemble all your best shots in front of you, including the ones you took on self-assignments.

Eliminate the noncommercial—Study the photographs carefully and remove from consideration any that are not commercial in appearance. As you study each photograph, pretend you are an art director who has to

Mailed promotional pieces can be effective in stimulating client interest, but the same rules apply as to a portfolio.

Shown at left are two pages from an eight-page mailer. The cover sets a stylistic theme that is emphasized throughout the entire brochure. Each page except the last contains only one, two, or three photographs. The last page is a collection of many images intended to demonstrate to an art director that the photographer can handle a range of photographic situations and has a broad background of experience.

Aside from immediately catching the eye of an art director, mailers serve a long-term purpose also: art directors often file them away for future reference. Sometimes a good mailer will generate jobs even years after it was first sent out.

use that shot in an ad. Ask yourself, "Can this photograph support a commercial message?" If you must answer no, remove the shot.

Eliminate those photographs that do not reflect a consistent style—Try to find stylistic patterns in your work, and then remove any photographs that seem at variance with the patterns you perceive. Are all your photographs soft-focus except for a few? Eliminate the exceptions. Are most of your shots taken with a wide-angle lens? Eliminate the exceptions. In all except a few of your images do dark tones predominate? Eliminate the exceptions. Similarly, look for aspects and elements common to most of your photographs and emphasize those while minimizing the deviations. Continue eliminating photographs until you feel that they all reflect a common style.

Eliminate yet another photograph—When you are convinced that all the photographs left contain common elements of style, eliminate still one more from the group. Look for the weakest image and remove it. If that was easy to do, remove one more. The result will be that you are left with a collection of photographs representing the very best of your work, all of which are commercial and reflect a cohesive style.

Refining your portfolio • Your portfolio evolves as you and your career progress. At the first meeting you ever have with an art director, your portfolio will consist only of a collection of photographs you *think* are good. At each interview, if you are alert, you will detect clues that will tell you which photographs are strong and which are weak. As you complete actual assignments, you will have material to substitute for the weaker images, and you will have "tear sheets" (samples of your work as actually used by a client) to include also. Throughout your career you will be replacing the weakest photographs in your portfolio with newer, stronger images that will better represent your talents. In short, for as long as you continue soliciting work as an assignment photographer, you will be paying constant attention to the contents of your portfolio.

Do not ignore the physical makeup of your portfolio. It should present an organized, dignified look that reflects well on you and your photography.

Shown at left are the main constituents of a representative portfolio. The backbone is a collection of 5" × 7" color transparencies mounted in sheets of 11" × 14" cardboard. Also included are a few 11" × 14" sheets containing 2¼" square transparencies. (35mm transparencies could have been used instead.) While the 5" × 7" photographs remain in the portfolio at all times, the sheets of smaller photographs are switched to fine tune the portfolio to the anticipated needs of a particular art director. The tear sheets have been mounted on black cardboard and laminated.

Notice that even though three very different elements are included–large transparencies, small transparencies, and tear sheets–each type is handled similarly. As a result the portfolio projects a feeling of consistency and is easy for an art director to handle and view.

PRESENTING YOUR PORTFOLIO

Almost as important as what you present is how you present it. Take great care to make certain that your presentation is effective. We will discuss the various means you have for displaying your work below, but some principles apply to all.

Make your photographs look valuable • Your presentation should not be flamboyant, but it should suggest that you value your work highly and that the art director should too. Do not expect to earn Rolls-Royce fees from a Volkswagen presentation.

Be consistent • Treat all your work similarly throughout your presentation. Do not mount some transparencies on black cardboard and some on brown or some on 8″ × 10″ mounts and others on 11″ × 14″ mounts. Consistency results in a unified look.

Organize your work logically • Arrange your work so that the viewer sees what you want him to see when you want him to see it. Go through your presentation many times until you develop a feeling for which photographs should be first and which last. Make sure all are oriented in the same direction. Especially important, make sure that the first and last items a viewer sees are among your strongest.

METHODS OF PRESENTATION

35mm slides • One method for presenting your portfolio is to mount 35mm slides in 2″ × 2″ holders and insert them in an 80-slide tray. The method is convenient; however, you must have at least sixty images of portfolio quality to show.

Advantages—Slide trays allow you to present a large body of work conveniently; your photographs are viewed in a definite order; you control the pace of the viewing by controlling the projector.

Disadvantages—You must carry a projector with you; the room where you are making your presentation may have no blinds; it is always slightly undignified to have to fumble around with cords; the equipment may

break down; the heat from the projector bulb could damage the slides.

Hints—To include tear sheets in your presentation, photograph them on slide film.

To avoid showing slides upside down, place a mark on the bottom of each slide that will be readily apparent when the slides are properly inserted in the tray. Another method is to place all the slides properly in the tray, then draw a spiral pattern on the bottom of the slides running from the outer edge of the tray to the center. Breaks in the spiral will reveal at a glance any slides that are upside down or out of order.

Transfer the individual frames of film from the cardboard holders to glass mounts made from special anti-newton-ring glass. The glass keeps all the slides focused properly in the projector, protects the slides, and provides a much sharper frame around the image on the screen than cardboard mounts.

Kodak Carousel projectors are the standard used by art directors. Many art directors will already have one set up, eliminating the need for you to use yours. Sometimes you can send along a slide tray for an art director to view without your having to be present.

When you show the slides yourself, you can control the pace of the presentation. Show one slide every two to three seconds. Stop occasionally to alter the rhythm, and stop anytime the art director asks you a question about a slide.

For a sophisticated appearance, neatly cover the box that holds the carousel with black contact paper. Glue a business card on top for a nice finishing touch. (In any event, always include your name somewhere on the box, the carousel, and each slide.)

Prints • Another method for presenting your work is by enlarging your transparencies or negatives onto photographic printing paper.

Advantages—Your presentation can contain as few as fifteen images, as long as they are of very high quality; adding and removing images is very easy, as is changing the order of photographs within the presenta-

tion; no special lighting arrangements are required to view the photographs.

Disadvantages—You cannot show more than approximately twenty-five photographs this way or else your presentation becomes too bulky; large color prints are expensive to prepare.

Hints—Prints can be any size, but generally, the closer to 11″ × 14″, the better. In any event, all prints should be the same size. If you include a two-page tear sheet, the prints will have to be at least 14″ × 17″.

Protect the prints by inserting them in acetate mounting sleeves. For the most appealing effect, use sleeves that are one size larger than your prints. Because of the black paper inside the sleeve, an attractive black border appears around the prints. Use tape on the back of the print to keep it from shifting, and center it within the sleeve. Replace the acetate sleeves when they become scratched.

Transparencies • A third method for presenting your portfolio is to mount your 35mm transparencies on black cardboard sheets out of which rectangles have been cut to allow light to pass. Slides can be mounted horizontally or vertically, or both formats can be mixed on one sheet. Larger-size transparencies can also be mounted in this manner.

Advantages—Transparencies are easy to add to the portfolio; individual slides are easy to organize into specialized topics; mounting is inexpensive, especially if you cut your own mats; more images can be shown in a presentation than is possible with prints.

Disadvantages—35mm images are rather difficult to view unless enlarged.

Hints—Photography and art supply stores sell precut cardboard sheets, or you can cut your own out of Bainbridge board. Insert all transparencies in clear acetate sleeves for protection, mount the transparencies on the back of the sheets using tape, and then attach frosted acetate to the back of the sheets to diffuse the light and spread it evenly.

TEAR SHEETS

If you have any, include tear sheets—samples of your work as actually used by a client—in your portfolio. Present the tear sheets in the same manner as the rest of your presentation. If your presentation is slides, photograph the tear sheets on slide film. For a presentation of prints, have the tear sheets laminated. (Be sure to first mount the tear sheet on a black background if printing on the back side might show through.)

PORTFOLIO CARRIERS

Leather cases • Leather carrying cases provide a handsome means for transporting your photographs. You can buy empty cases or cases with bound-in acetate sleeves.

For transparencies, the empty cases enable a viewer to remove the sheets easily and to hold them up to the light, but for prints, the bound-in sheets have the advantage of keeping the pages in the desired order. If you buy the bound-in type, be sure that some method is provided for replacing the sheets when they become scratched.

You need not buy the most expensive case available. Just be certain the one you do buy is simple, attractive, and functional. Plain black is best.

To give your presentation a feeling of substance, buy a case that is at least $11'' \times 14''$, even if your mounted photographs are smaller.

Boxes • You can also buy attractive cloth-covered boxes into which you place loose, acetate-covered sheets. Again, black is best.

Attaché cases • Attaché cases are similar to the boxes described above, but have handles. These cases can be quite expensive, but have the advantage of making a heavy portfolio easy to carry. The biggest disadvantage of both attaché cases and boxes is that the contents are constantly being rearranged by art directors.

Self-Promotion

Once you have a strong portfolio, you need to be able to bring your name and your work to the attention of the people in a position to hire you. In other words, you must spend time and money promoting yourself.

PROMOTIONAL PIECES

One method you can use to make your presence known is to prepare printed flyers and brochures to give to prospective art directors. High-quality printed promotional pieces make a favorable impression, legitimize your claim that you are a formidable photographer, stimulate calls to see your portfolio, provide a form art directors can use to keep your name on file, and provide art directors with ammunition they can use to convince *their* clients that you are the person for the job.

If you have something printed, be sure it shows you off favorably. Nowadays, so many photographers are mailing promotional pieces that unless yours looks sophisticated and expensive, it will not receive much attention. If feasible, obtain design help from an art director friend, or hire a freelance or moonlighting art director. The added expense will be worth it to make sure that your ad generates a strong response.

Other types of promo pieces you might consider having printed are posters and calendars. One photographer we know selects twelve portfolio-quality images every year and has them printed on separate cards, each with a different month's calendar. Monthly, she sends a new calendar to each art director on her mailing list.

Design • In designing a promo piece, use the same selection criteria for photographs as with your portfolio. Do not be tricky; you are selling photography, not art and design. The design should be subordinate to your photography. If funds are a problem, even a simple 5″ × 7″ card, containing a single photograph along with your name, address, and phone number can be effective either to mail or to leave behind as a calling card when you see an art director.

Who to mail to • You will obtain the best response if you mail directly to art directors and creative directors by name at advertising agencies and graphic design studios. For the names and addresses of small, local agencies, consult the Yellow Pages, then call the individual agencies, and ask for the names of the art directors the agency has on staff.

For larger agencies, those that have at least one national client or multistate accounts, consult the *Standard Directory of Advertising Agencies* (National Register Publishing Co., Skokie, IL 60077, $52), which is available in many libraries. The book lists the names of advertising agencies alphabetically and is cross-referenced by city and state. You can look up all the agencies in your area and obtain the names of agency personnel. Should you ever want to do a mass mailing, you can buy lists of the names in the book printed on self-stick labels.

ADVERTISING

In the last five years there has been a pronounced shift by photographers to placing self-promotional ads in some of the specialized trade publications that art directors see. Indeed, the practice has become so widespread that the impact of individual ads is becoming diluted. Such ads in national publications are quite expensive, but some of the regional publications have more reasonable rates.

The best known—and most expensive—publications are *Art Direction* magazine (10 East 39th St., New York, NY 10016) and *The Creative Black Book* (Friendly Publications, Inc., 80 Irving Place, New York, NY 10003). Both publications will send ad rates upon request.

Be sure to obtain some design advice before you spend money to take space in a publication.

Maintaining your portfolio and promoting yourself are continuing tasks that you may consider an unwelcome burden. Always bear in mind, however, they are tasks that in many ways are as important to your success as is your talent. ∎

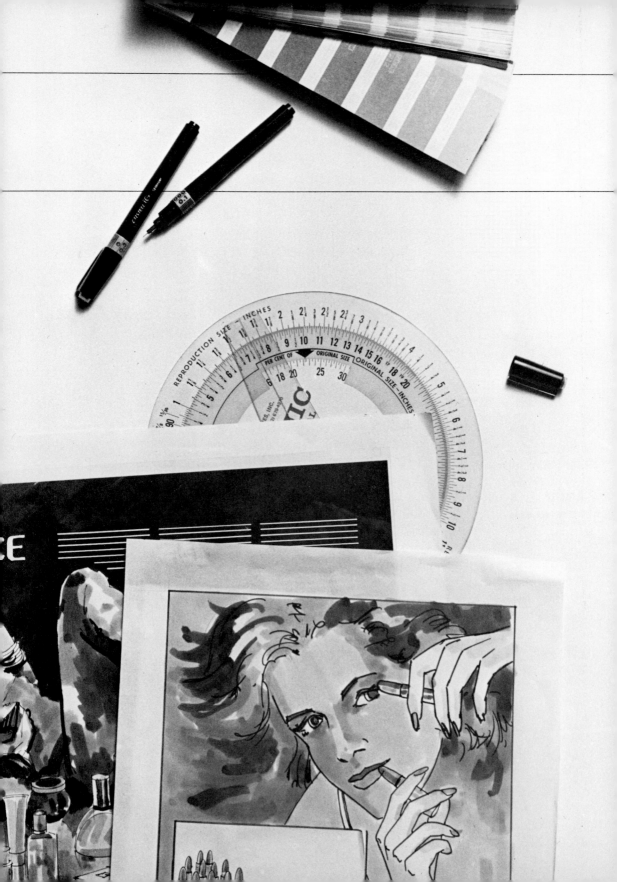

DEALING WITH YOUR CLIENT

6

Once you have put your portfolio in order and attracted the interest of people who would like to see your work, you are going to undergo a series of interviews. Therefore, you should know with whom you will be dealing and how to handle yourself while you are discussing your work with potential clients.

WHO *IS* YOUR CLIENT?

Most frequently you will be dealing with an "art director," although you may occasionally be confronted with a "creative director" or an "art editor." These titles will apply whether you are working with a commercial advertising agency, directly with the actual consumer of your photographs through the in-house agency of a business firm, or with a magazine or newspaper. These are the people to whom you will need access.

ARRANGING APPOINTMENTS

If you have sent a mailer as described in the previous chapter, you may receive calls from art directors or their secretaries asking you either to bring over your portfolio or to send it over separately. As an alternative, you can simply telephone agencies and ask for an appointment.

The disadvantage of using the telephone over sending mailers is that the interviews you are granted over the phone can result in your spending many hours talking with art directors who have no need for your type of work. An art director who has responded to a mailer has already seen a sample of your work and knows that your photography is likely to meet his or her needs.

Use the same sources of names as discussed in the previous chapter: the Yellow Pages and the *Standard Directory of Advertisers* ("The Agency Red Book").

The best time to call for an appointment is on a Monday morning when everyone is fresh and before the art director has filled up his or her week's schedule. When you talk to an agency's receptionist, ask for the art director by name. If you are asked to reveal the nature of your business, state that you are a photographer and want to arrange an interview to show your portfolio. Part of an art director's job is to be aware of the talent available in the area, so your call will be put through.

To save your time and that of the art director, when you speak to him, diplomatically try to determine his specialty by saying something like: "I don't want to waste your time, so may I ask what type of accounts you usually handle?" If you specialize in still lifes while he normally concentrates on fashion, explain the conflict, thank him for his time, and try someone else. You should be able to arrange five or six appointments in an hour.

Another advantage of asking him his specialty is that the knowledge will allow you to slant your portfolio toward his needs. If he shoots liquor accounts and you have a liquor shot that you had not planned to include, you can add it before you go for the interview.

One note of caution. When you are first starting out, do not approach your best prospective clients first. Your first few interviews are really for practice and to identify shortcomings in your portfolio. Expect a few of your early interviews to be disasters or, more charitably, "learning experiences." You do not want to risk ruining your chances with a potentially good client until you have refined your presentation based upon the knowledge you gain during your first few interviews.

THE INTERVIEW

You are selling confidence • More than anything else, at the interview you are trying to convince the art director that he or she can have confidence in your abilities. Your portfolio will sell your technical and creative skills, but you will have to sell your personal traits. No matter how good your portfolio, if the art director senses that you do not have the poise or experience or

temperament to handle a real shooting, he or she will not be willing to take a chance on you. Every word you speak and every move you make should reinforce the idea that you are a competent, conscientious professional.

Be punctual • Arrive on time for the appointment. Even though you will probably be kept waiting, be on time. One of the points you are trying to make is that what you promise, you deliver.

Dress neatly, but casually • Do not overdress by wearing a business suit, but be careful not to look sloppy. Art directors as a rule are casual, but an art director might well conclude that a person who is careless in his appearance will also be careless in his photography.

Let your portfolio speak for itself • Do not try to sell your portfolio. If the art director asks about a photograph, discuss it. Do not, however, brag about how talented you are. He or she will know that within thirty seconds of starting to look at your work. You can discuss the background of individual photographs if you are asked about them, but beware of seeming boastful. Show confidence, be assertive, but do not be arrogant, cocky, or pushy.

Do not try to sell more than one job • If you have been asked in because the art director is looking for someone to shoot a shoe account, do not try to convince him that if he ever needs someone to shoot fashion, you are just the person. Concentrate your focus on the job at hand.

Be personable • Because you want to make a lasting impression, anything favorable you do to make you stand out in his memory will be helpful. Try to steer the conversation onto a personal level. Ask the art director where he is from, or where he got his training, or something about his accounts. Comment on what you see in the room. But be careful not to seem nosy.

Observe the art director's reactions • Use the interview to learn as much as you can. You will find that you look at your photographs differently as you watch over an art director's shoulder. Note which photographs the art director lingers over. Remember which ones he or she asks questions about. Later, you can use the information in refining your portfolio.

Do not expect to walk out with a job • At best, you will be called in a few days. At worst, you will hear nothing for months and then suddenly receive a call asking you to bring in your portfolio again. You are planting seeds when you attend an interview; be willing to give them time to mature. In any event, at least once a year—more often, if you wish—you can ask for another interview to show your most recent portfolio.

NEGOTIATING A FEE

Photographic fees are based either upon the usage to which a photograph will be put or upon a photographer's day rate, or both.

Usage • Fees based upon usage reflect the exposure the photograph will receive and/or the cost to the advertiser of placing the ad in which the photograph will appear. The more widely the photograph will be distributed and the higher the "insertion" costs (that is, the higher the advertising rates) of the publication or publications in which the ad will be placed, the higher the fee a photographer receives.

Day rates • Every photographer sets a day rate—that fee he or she receives for a day's shooting—calculated on the basis of the photographer's talent, experience, geographical location, and ability to convince an art director that he or she is worth that much money. An experienced photographer's day rate is equal to the fee he or she receives for shooting a national ad. When you are just starting out and national ad assignments are not likely to come your way, you will have to base your day rate on an assessment of how powerful your portfolio and credentials are. Set your rate too low, and you will not be considered a very good photographer; set it too high, and you will not be given any assignments.

A day rate serves two main functions: it indicates where you fit relative to other assignment photographers; and in some circumstances it acts as the minimum fee that you will receive for a given assignment. For example, sometimes a client will need a photograph without knowing how extensively the photograph will ultimately

be used. Perhaps the photograph is for an ad campaign that will be test-marketed in a limited area. Should the campaign be successful, one or more of the photographs from the shooting might end up being used nationally. In such circumstances you would agree to shooting at your day rate, but with the understanding that you would receive more money should the fees you are entitled to on the basis of ultimate usage exceed your day rate.

In all likelihood, when you are first starting out, you will not be asked your day rate, but you will be asked to quote a fee for a specific shot. The chart on page 86 will give you an idea of the going rates, but remember that fees are always subject to negotiation. One good tactic is to listen to a description of the job and say something like: "Well, for that kind of job I would normally charge $500. But if that's not in your budget, tell me. Maybe we can work something out." The amount you quote ($500 in this example) should be on the high side of the range given in the chart for the type of shot you are discussing. If what you have suggested is approximately equal to the amount the art director expected to pay, he or she may simply agree to your fee. (Since in most cases your fee will be marked up and passed along to the art director's client, there is little incentive for the art director to convince you to lower your fee as long as what you ask for falls within his budget.) If he thinks your fee is too high, your having already indicated your willingness to negotiate should prompt him to inform you that his budget does not provide as much as you are asking.

At this point, you can just ask him what his budget allows. Most art directors will tell you, and then you can decide if you are willing to accept that fee. A warning is in order, however: if you agree to too low a fee, in the art director's eyes you will be a second-rate photographer. He may use you again on other small jobs, but once his budget increases, he will turn to a more expensive photographer in the belief that quality costs extra.

Usually, the best policy is to decide before you actually start negotiating the lowest fee you would accept for the job; then stick by that decision. If the job includes fees for more than one shot, it is customary to give a volume discount.

Going Rates for Photographic Assignments

Category	Variability (+/−), %	Local distribution/limited circulation/ limited print run	Regional distribution/moderate circulation/moderate print run	National distribution/unlimited circulation/unlimited print run
Advertisements				
Consumer	25	$500	$1,000	$2,000+
Trade	25	$350	$ 500	$1,000
Newspaper	25	$250	$ 350	$1,000
Annual reports		Photographer's day rate		
Billboards	25	$500	$1,000	$2,000+
Book covers	30	$300	$ 500	$1,000
Brochures	50	$300	$ 700	$1,000
Catalogs				
Cover	25	$300	$ 500	$1,000
Inside	50	$100	$ 200	$ 500
Editorial illustration in magazines and newspapers		Based upon publication's standard rates—wide variability dependent on circulation and prestige of publication		
Packaging	30	—	$1,000	$2,000
Point-of-purchase displays	30	$400	$ 600	$1,000
Record album covers	25	—	$ 400	$1,000

Most important during negotiations is that you not box yourself in. As long as the fee you are discussing lies above your cut-off point, allow yourself room to maneuver. You cannot gracefully say in one breath that $400 is as low as you can possibly go and then accept $350.

JOB ESTIMATES

Sometimes a client will want you to prepare a formal estimate for a job. This request is not unreasonable considering that in many instances, the overall cost of the shooting will be substantially greater than your fee. To prepare the estimate, you need to commit to writing not only the fee you have agreed upon, but also your projections of any other expenses that the client will be required to bear. The key to preparing an accurate estimate is to ask enough questions to know precisely what the shooting will entail. Do not be afraid to call the client to clarify anything about which you are unclear.

Billable expenses • Your estimate should cover any of the following categories that apply to the particular job (some of these categories are covered in greater detail in later chapters): your fee, the cost of film and processing, models' fees, stylist's fee, hair and makeup artists' fees, long distance phone call charges associated with shooting on location (location search expense; location use fees; travel, food, and lodging expenses; cost of renting an equipment van), prop purchase and rental, set construction (labor and materials), and expenses for feeding participants during the shooting (note that you will be expected to arrange for lunch if the shooting occurs around noontime, but the cost is billable).

Most of these items you will be able to estimate fairly accurately, especially after you have completed a few assignments. Be careful with the estimate for styling, however. (As discussed in detail in Chapter 11, the stylist provides props for a shooting.) To derive the estimate, you will have to explain the nature of the job to the stylist, who will quote you a fee. If the actual styling expense turns out to be far higher than the estimate, you

will be blamed. A few stylists routinely submit written estimates; however, most do not. To protect yourself, after you have been given a styling estimate, send the stylist a short memo summarizing the requirements of the job and indicating the agreed upon fee. This will imply that you expect the stylist to adhere to the estimate and that you should be notified immediately if the expenses are running higher than planned.

Nonbillable expenses • The following expenses you will be expected to absorb yourself: the cost of a photographic assistant (if the job requires more than one, the fees of the additional assistants are billable), rental equipment (except specialized equipment required by an out-of-the-ordinary shot), studio expenses (unless a special studio is required), and studio supplies (seamless paper, lighting equipment, etc.).

PREPARING TO SHOOT

Preproduction conferences • Depending on the complexity of the job and the client, you will need to participate in one or more conferences in advance of the shooting to familiarize yourself completely with the job. Sometime before the shooting you will be shown a layout: the art director's detailed sketch of the photograph he or she wants and the way it will ultimately be used. At this stage you will have the opportunity—and obligation—to inform the art director of any major problems you foresee. For example, sometimes art directors will visualize a photograph that is technically impossible to create (for instance, a scene shown with a perspective requiring a wide-angle lens but with models positioned in such a way that the lens would distort their appearance). In addition, having the layout will enable you to ask questions and decide exactly what you will need to do to prepare for the shooting.

Be ready • As we have already stressed, you should always be ready at the agreed-upon shooting time. Even if there is no one involved but you and the art director, you should start the shooting promptly. When models, stylists, hairdressers, and others being paid by the hour are also involved, punctuality is critical.

Always remember that you alone are ultimately responsible for the success of the shooting. You are in complete command, and you will be blamed if something goes wrong—even if something happens that is beyond your direct control. Above all else, your job is to be sure that the client ends up with usable film, so be certain to check and double-check everything you can before the shooting. Here are some specific suggestions.

Have backups—Do not rely on any one critical item of equipment. Have on hand at least two camera bodies. More than one photographer has had a single camera available only to have it break down during the shooting.

Pretest all unfamiliar equipment—Rented equipment is notoriously unreliable. Pick up rented equipment far enough in advance of a shooting to have time to shoot a test roll of film. Do the same with newly purchased or newly repaired equipment. Also it does not hurt to run a test on a new batch of film to check for defects.

Double-check everything—Just before a shooting, quickly check everything again, or have a reliable assistant do it. You cannot be too careful.

DURING THE SHOOTING

At the time of the shooting not only will you have to worry about the photography itself, but you will also have to deal continuously with the art director. Art directors' demeanors range during a shooting from comatose to hysterical, depending on the particular art director's personality. The calm ones are easy to handle; the others may try your patience.

The "nervous Nellie" • One of the worst types you can encounter is the "nervous Nellie." This type is so worried that the shot will fail that he makes everyone else nervous too. Moreover, he may well give you conflicting instructions during the shooting; he may even tell you to abandon the original layout entirely.

Always cover your bases. Be tactful, but exert pressure as needed to make sure that you get at least *something* usable during the shooting. If the art director comes up with a completely new idea, say something like: "Your

idea is difficult to do, but really interesting. Let's follow the layout first and then give your idea a try." What you want to avoid at all costs is finishing the shooting without having obtained at least one photograph that meets the requirements you were originally given.

Too many chiefs • Another potential disaster occurs when too many people all think they are in charge. Sometimes the art director is accompanied by a number of other people from the ad agency or its client company, each of whom feels qualified to give instructions. Make clear to everyone whom you consider the person in charge—usually that will be the art director—and then follow that person's directions. When others try to tell you what to do, tactfully explain that you feel it best if only one person is in charge and would they please discuss their ideas with that person.

Be prudent • While you are shooting, there are some precautions you can take to help minimize the chances that you will suffer the fate of the imprudent photographer: all your film comes out unusable.

Shoot on two camera bodies—Do not let that second camera body sit around to be used only if the first one becomes obviously broken. Shoot the entire job on both cameras. If one is defective, you will still have usable images on the other. If the job involves more than one shot, each time you change sets or models or poses, you should shoot at least a few frames on both cameras. Even on a small job that requires less than a single roll of film, you are better off wasting a few frames by shooting two rolls of film than relying on only one camera body.

Use plenty of film—Film is probably the least significant expense you will incur during a shooting. Do not hesitate to use as much film as you need—and then some. Because you never know when a frame will be damaged in processing, make sure that usable images are found on more than one frame.

Bracket your exposures widely—You never know when your exposure meter is giving you a faulty reading. Moreover, sometimes conditions are such that the best exposure turns out to be different from that indicated by

the meter. Therefore, over- and underexpose your film widely in half-stop increments, especially if you are shooting color film.

Split your film—On very important assignments, particularly assignments that incur high model fees or location expenses, split your film up so that the entire batch cannot be lost or damaged during one processing session. Develop half and then send out the rest only when the first batch has been safely returned.

EDITING RESULTS

Remember that your client is as excited about the shooting as you are. Since he knows that if the shots come out well, he will look good to his boss and his client, he will eagerly anticipate seeing the results. At the same time, however, in the back of his mind he will be worried that the shooting was a failure. In preparing the results for presentation, you want to immediately make sure that his reaction will be positive.

Editing slide film • First, go through all the returned film with an eight-power magnifying lupe and discard the exposure brackets, scratched slides, and any other images that have a major aesthetic deficiency (the model's eyes are closed, a fly is perched on the subject, etc.). Align all the slides so that they will be easy for the art director to view.

Second, select the photographs that you consider to be the very best from the shooting, mark them in some manner, and segregate then from the other slides. Art directors often overlook small technical imperfections—a slight softness in a corner of the image or a small, undesirable reflection, for example. By not including these among the best images, you save the art director from possible later embarrassment. Moreover, many art directors will ask your opinion anyway, so anticipating the request is a thoughtful gesture.

If you will be sending more than one box of slides, mark each box appropriately to distinguish its contents. Send the slides you thought to be best in a separate box, clearly labeled. Another thoughtful gesture is to place the best slides in a slide tray, so that the art director can put them immediately into a projector.

Prints • Because with prints you will be sending contact sheets, the procedure is somewhat different from that with slides. Check each negative carefully under a lupe. On the contact sheet, draw a line with a grease pencil through any images that are scratched or otherwise unusable. A thoughtful gesture is to enlarge one or two of the best images to send along to the client. Retain the negatives yourself. The client will notify you later if he or she needs any other frames enlarged.

Portfolio photographs • Whenever possible, retain one or more images from a shooting to include in your portfolio. If you have shot as much film as prudence dictates, you should have enough images available to hold onto one or two and still send the best to the client. In the event the image you like best for your portfolio must be sent to the client (the best image for your portfolio is often different from the image that best meets the client's needs), you can request that he return it to you if he does not use it. With negative film, you retain all the images anyway, so you can make prints of whichever you like.

BILLING THE CLIENT

Technically, you can bill the client as soon as the shooting is completed; however, too much haste is unseemly. Once the film has been processed and sent to the client, you should type up the invoice and send it out. Delaying longer makes it more difficult to remember the details of the shooting and hurts your cash flow.

RESHOOTS

Hanging over every shooting is the threat that some disaster will cause the shooting to be a complete failure. Your responsibility in the event of such a failure depends on what happened.

The failure was unquestionably your fault • If, due to some technical problem such as defective equipment, no usable images came out of the shooting, the obligation is yours to reshoot without another fee. In small, uncomplicated shootings, a reshoot presents little more than an annoyance, but when heavy collateral ex-

penses such as model or travel fees are involved, the problem is more complex. In theory you should absorb all expenses, but in actual practice the client will normally pick up the out-of-the pocket costs of the reshoot.

The failure was unquestionably the client's fault • Occasionally a client will decide after a shooting that he or she actually wanted the model to have a different hair color, or the concept of an ad will be changed, or for some other reason due to no fault of your own the photographs you took are not usable. In such a circumstance the reshoot is clearly the responsibility of the client, and the reshoot should be considered an entirely new shooting, with you entitled again to your full fee.

Responsibility for the failure is mixed • In gray situations where responsibility is difficult to affix, you will have to be reasonable and flexible. Remember that if you help the art director out of a jam, he or she will be grateful and probably bring you work in the future. If you appear arrogant, obstinate, or unreasonable, you may end up gaining a few extra dollars but losing a client. Be willing to reshoot for half fee or for two-thirds fee for the reshoot and the next two jobs the client gives you. Be creative, and turn the problem into an opportunity to cement your relationship with your client.

An excellent strategy is to deal with the problem of reshoots before you even start the shooting. Let the client know that your goal is to make sure that he gets the shot he needs. Make him understand that if the shot does not work out, your policy is to do what you can within reason to help him out. By so informing him, you will clear the air of much of the tension that surrounds a shooting and help alleviate some of the very conditions that contribute to failure. Occasionally, you will encounter an art director who will abuse your goodwill, but most will be grateful and reward you by using you regularly.

Even though the actual shooting usually constitutes only a small part of the time and energy you must devote to an assignment, the shooting is the climax of the entire process. By maintaining a calm, reasoned, professional demeanor throughout, you will set a tone that will help ensure the shooting's success. ■

Layouts.

At right are layouts typical of those an art director might prepare for any commercial assignment. The quality of the artwork on these is somewhat above average, but you should be able to tell from any layout what the art director has in mind for the shooting. Always bring to the art director's attention any problems you foresee, and suggest solutions.

It often pays to verify important information. In this shooting two days were lost because although the model appears in the layout to have blond hair, the art director actually wanted dark hair.

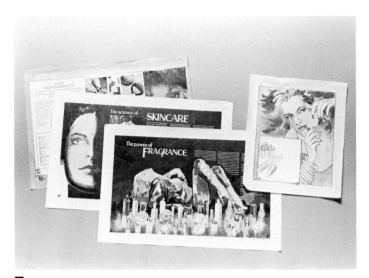

Every assignment is a little bit different from every other, but many common elements exist. On these pages we describe a typical studio assignment. Notice as you read the importance of clear communication between photographer and client.

The assignment was to take five photographs for the new Avon catalog. Close coordination and careful planning were necessary to compress the entire shooting into a single day.

A week before the shooting the art director sent down layouts. She had already decided that she wanted 35mm for the four-color photographs and 2¼″ square for the single black-and-white. However, I suggested that we shoot the model on 35mm film and the bottles on 4″ × 5″ film and then "strip in" the bottles in front of the model later.

I divided the day into morning and afternoon sessions. I knew I could use almost identical lighting setups in three of the shots, so I planned them one after another. For efficiency, the art director and I selected an order of shooting that would simplify hair and makeup changes.

The pace we maintained during the shooting was comfortable, but steady. Primarily because everyone was experienced and well prepared, the shooting went smoothly and we had no problem completing the assignment on time. ∎

9:00 A.M.

The hair-and-makeup artist begins
working on the model in a procedure that
will take almost two hours. Because the
subjects of the photographs are personal
grooming products, proper hair and
makeup are especially important.

9:30 A.M.

The photographer and the art director
further discuss the layouts and fine tune the
day's shooting schedule. In particular, they
decide upon the exact order in which the
shots will be taken. The stylist is informed
so that she can have the appropriate clothes
ready on time.

10:45 A.M.

The art director and the stylist work
together with the model to fit the clothes,
pinning where necessary. Far more clothes
have been rented for the shooting than will
actually be used, but having a wide
selection to choose from is important to
guarantee that any contingency can be
dealt with easily.

11:00 A.M.

The model is in place for the first shot
and the stylist is making last-second
clothing adjustments. Although while the
model has been getting ready the lighting
has been prepared and is ready to go, final
checks are made with the model in place to
verify that exposure settings are accurate.

Because the model is a highly experienced
professional, she will be adept at posing and
will help ensure that the shooting adheres to
the tight schedule.

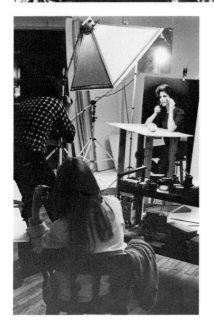

11:30 A.M.

The first shot is completed and the second
is under way. The lighting is essentially
the same, but the model's hair has been
altered slightly and a different background
slipped into place.

In the foreground the hair-and-makeup
artist is monitoring the shooting and will
make any adjustments to the model's hair
or makeup that become necessary.

12:30 P.M.

While the model is being prepared for one of the shots, the photographer is eating lunch. While the model is eating, the photographer will be preparing the next set.

1:00 P.M.

In addition to monitoring the shooting, the stylist must also carefully manage the clothing the model is to wear. An iron and ironing board are kept nearby to touch up any wrinkled areas. The stylist must always stay at least one shot ahead of the photographer. Delays caused by an unprepared stylist are inexcusable–and extremely frustrating.

2:00 P.M.

The most difficult and time-consuming shot of the day commences. The shot requires four different clothing changes and two different lighting setups for each change. The process could have been speeded up by using two separate sets. In situations like this the photographer must keep a careful eye on the clock.

3:30 P.M.

Yet another clothing change and light setup. This setup is similar to that used in the morning. These shots will be close-ups in which the model's hair will not be important, so the shots were left to the end of the day when hair tends to lose its body anyway. Notice in the model's attire that attention is paid only to what the camera will see.

4:00 P.M.

The final series of the day begins. These are a few macro shots of the model applying makeup that were originally scheduled as bonus shots–shots that were to be done only if time permitted.

The entire shooting is completed by 4:30 P.M., a half hour ahead of schedule. The art director has the developed, edited film in her hands within 36 hours.

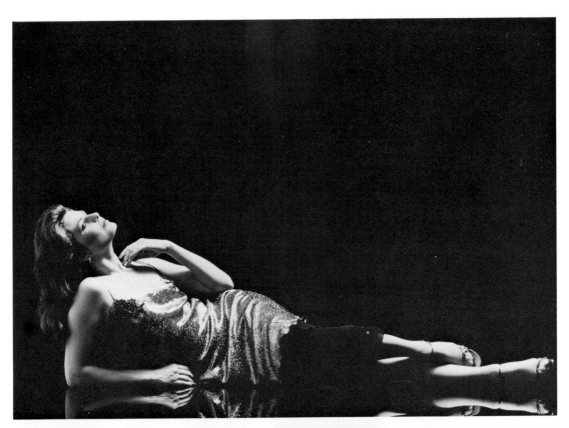

These are some of the actual photographs taken during the shooting described on the previous three pages.

STOCK PHOTOGRAPHY

7

This chapter was prepared by Henry Scanlon, the Executive Director of Photofile International, Ltd., one of the world's most successful and prestigious stock photography agencies. He is the author of a comprehensive book on stock photography entitled You Can Sell Your Photos *(Harper & Row).*

Over the last decade, working professionals have become increasingly aware that existing or "stock" photography plays a critical role in the development and enhancement of careers. Photographers who understand stock photography markets, who know how to shoot for and exploit those markets, have a tremendous advantage over their less informed (or less enterprising) compatriots. Here, I will present the fundamental information you should know about stock when you are starting your career.

WHAT *IS* STOCK PHOTOGRAPHY?

Anyone who needs a photograph—an art director, a photo buyer, a graphic designer, a greeting card manufacturer, a calendar company—has two ways to acquire it: he can hire you or another assignment photographer to go out and shoot to his specifications, or he can purchase the *use* of a photograph that already exists. The latter is called a "stock" photograph. If the buyer decides he wants to purchase a stock photograph, he either contacts individual photographers or, more often, calls one of the many stock photo agencies. These agencies keep thousands of photographs belonging to many photographers conveniently organized under one roof.

WHAT STOCK PHOTOGRAPHY MEANS TO YOU AS A PROFESSIONAL PHOTOGRAPHER

Found money • First and foremost, stock photography can be an additional source of income to augment what you receive from your assignment work. Indeed, because once a photograph has been produced it costs the photographer nothing more in the way of production expenses to sell it again and again, many photographers view their stock photography sales as "found money."

Financial equity • Second, stock photography offers you one of the very few ways you have at your disposal to build up *equity* in your own career. That is, once you have produced a body of work with market value and are marketing it effectively, even if you should retire or no longer be capable of producing photographs, your stock files can provide you with a continuing source of income. The body of your photography becomes your equity, the income from them your dividends. The extent to which you actively expand and improve your collection of marketable stock photographs over the course of your career determines the value of your equity when you retire.

The potential value of your stock photographs can be illustrated by the fact that, whereas in the past most stock photographs consisted of out-takes (photos not submitted to a client) and seconds from photographic assignments, today more and more photographers build their *entire careers* around their stock sales and relegate assignment work to a backup role. In effect, these photographers spend their careers shooting assignments they give *themselves* rather than assignments they are given by others.

How much can you make from stock sales? Annual incomes range from a few dollars to well over $100,000. How much *you* can make will be determined by three factors: your ability to produce images that photo buyers need; your energy, enthusiasm, and aggressiveness in producing those images; and the levelheadedness and savvy with which you promote your product in the rigors of the marketplace.

HOW TO PRODUCE MARKETABLE IMAGES

Effective stock photos convey moods and ideas • I cannot tell you what to shoot, but I can tell you the one thing that separates those photographers who make money from their stock photos from those who do not (and it has nothing to do with the technical or aesthetic aspects of their photography, which I assume in both cases are of a high level): *photographers who make money in stock produce images that capture the same moods and ideas that photo buyers need to convey*. Reaching that goal may sound simple, but often it is not. Consider, for example, the waterfall shown on page 105. It looks routine, although, in fact, the photographer, lugging camera equipment deep into the woods, had to return to the scene several times in different seasons to get the shot he wanted. He was after more than simply a pretty scenic; he wanted a shot that could convey the feelings of "freshness," "purity," "coolness," and "spring" —all concepts that he knew photo buyers could put to good use in their ads, brochures, and the like. Was the photographer right? So far the photograph has sold thirteen times for revenues of over $7,000. It has been used on record albums, in magazine ads for sound equipment (waterfalls have *sounds* too), brochures for water purifiers, moisturizers, and on and on. Because the photograph triggers responses in viewers, it works for photo buyers, and they buy it, over and over again.

On page 106, the shot of rolling sand dunes from Arizona works on several levels. As a travel scenic it dramatically conveys a sense of place. In addition, a photo buyer can use it to describe the concepts of dryness, or heat, or desolation, or emptiness—concepts of which the photographer who took the picture was very much aware as he was stalking the shot.

The same is true of photographs that contain models. A successful stock photograph does not merely show what people look like, it stimulates thoughts or reactions in the viewer. The viewer might wonder, albeit unconsciously, "What are the people in the shot thinking? What ideas do they express? For example, look at the

shot of the family on page 108. Imagine how an insurance company or a bank could use this photograph for brochures on family security.

No matter what your area of interest, from macro flower photography to heavy industrial subjects, if you are canny about what you are doing, you can pick up stock shots that can earn extra money for you. Flower shots are often used as backgrounds to lend color and texture to otherwise mundane promotionals. The shot of the beakers on page 110 can be used to connote research and development, medical experimentation, or pharmaceutical interests—a host of different applications, all potential moneymakers.

Travel • Never overlook the potentials of travel photography. You see travel photography in tour brochures, airline and hotel ads—anything relating to the travel industry. Most of the photographs you see in such ads and brochures were purchased from the files of stock agencies or individual photographers.

Key Shots—To be a successful travel stock photographer you must learn how to "cover" a location quickly and efficiently. That means that you must produce a "key" shot of the locale—a graphic, striking photograph that immediately "says" the place in question. For example, if you were attempting to cover New York City, your key shot might include the Empire State Building or the Statue of Liberty. If you study travel brochures, you will see that the key shot is usually large and acts as the center of interest of the entire spread.

Satellite Shots—Once you have located and photographed your key shot, concentrate on obtaining supplementary "satellite" shots of the area. Satellite shots illustrate the attractions of the locale and suggest to viewers the activities in which they can engage once they arrive. For New York, these shots might show such locations and activities as Broadway, shopping on Fifth Avenue, dining in an elegant restaurant, taking the ferry to Staten Island, and so on. To the extent that you are able to convey those concepts with your camera in forthright and interesting ways, you will be producing salable travel photographs.

Preplanning—Having an idea what you are going to shoot *before* you arrive is vastly preferable to the "shotgun" approach where you shoot like crazy and hope in the end you have covered everything. Plan ahead. Read already existing travel brochures or anything else that will help you anticipate the important key and satellite shots. Remember: what might be easy to identify in New York or San Francisco becomes much more difficult in Boise or Brussels.

Characteristics of a good stock shot • By this time you may have noticed something about the photographic examples discussed above: all of them are essentially simple, uncluttered, straightforward photographs. That does not mean they were easy to take, but it does suggest that in order to convey ideas clearly, the photographers included in their photographs only those visual elements absolutely necessary. As a result, their photographs are characterized by simplicity, versatility, and graphic power.

Simplicity—By simplicity I mean that a stock photograph should seek out one specific element—a stream, a forest, a mountain range, a field of wheat—and concentrate on that element. If a scene includes both a mountain and a stream, to produce a good stock shot, you are going to have to take either a photograph of the mountain *or* a photograph of the stream. This does not mean that if you take a photograph of the mountain that the stream will not appear in it, or vice versa. But it *does* mean that if you produce a photograph in which the stream and the mountain have equal weight, your shot will be weak.

Versatility—By versatility I mean that a photo should be general enough to have many potential applications. For example, I have in my files well-crafted but unspectacular photos of rolling mountains in Pennsylvania that sell ten times more often than some breathtaking panoramas of the Alps. Why? Because for every client I have who needs a shot specifically of the Alps, I have a hundred who want shots of generic, simple mountain scenics suitable for anything from background for their product shots to unspecific mood pieces in their annual reports or sales brochures.

Furthermore, good stock photos incorporate neutral areas over which photo buyers can insert type or photographs of the product they are advertising. The larger and more numerous these areas, the more versatile the photo from a purely mechanical point of view.

Graphic power—By graphic power I refer again to the vital concept that a photo should create a mood or make a statement strongly, unambiguously, and without hesitation.

Look at all the magazines you can get your hands on and study both the ads and the editorial photographs. Find out what art directors buy and why. Learn to differentiate between stock photographs and those taken on assignment by reading the photo credits. Where you see that the shot came from a stock agency, analyze why that photograph was bought. What message does it convey?

Pick up travel brochures and study them. Develop a feel for the way photography is *used* to create coherent layouts. Then venture out and try shooting stock yourself. Give yourself assignments and then edit your results ruthlessly—just as a photo buyer would.

A WORD ABOUT FILM AND FORMAT

Photographers shoot and sell photography in every format and in both black-and-white and color. *However,* unquestionably, those photographers who are earning the most money in stock photography are shooting 35mm Kodachrome color transparencies (slides). It is as simple as that.

THE AGGRESSIVENESS FACTOR: WORKING AT STOCK PHOTOGRAPHY

The only way you are going to be successful at stock photography is by pursuing it as energetically as any other aspect of your career. If you have talent and are willing to work hard, you will make money. If you have talent, but are *not* willing to devote attention to your stock files, you will *not* make money.

A successful stock photograph conveys more a sense of meaning than a sense of place.

In this instance the photograph's impact stems from a feeling of wetness, remoteness, and isolation. Were this identifiable as a particular waterfall, the photograph would have far less value as stock.

Although you might receive an occasional request for a photograph of a particular place, a photograph is more likely to sell if it is nonspecific and supports the type of message an art director is likely to want to convey.

Relatively few art directors would want to say "Death Valley," for example, but many might at one time or another need to say "hot," or "dry," or "dust," or any of the other concepts that this photograph suggests. This photograph, in fact, although taken in the United States, has sold many times throughout the world to art directors who simply want to suggest the qualities common to all deserts.

I have been running a stock photo agency for eight years and in that time have spoken to literally hundreds of photographers who have wanted my agency to represent their work. Virtually every photographer assures me that he or she intends to devote a substantial amount of time and energy to producing stock; very few of them do. Their intentions are good, but they are not aggressive enough. Let me assure you that if you are willing to be aggressive—if you are willing to roll up your sleeves and enthusiastically get to work—the financial rewards can be enormous.

BUILDING UP YOUR FILES

Combining stock with assignments • While being paid by a client to shoot specific shots, you can allocate some of your time to producing images that you can put in your files for future sales. If your are an industrial photographer, for example, and have been given an assignment to shoot a manufacturing plant, you could produce the shots required by the assignment (photographs of the manufacturer's product coming off the assembly line, for example) and then spend some time taking generic shots of any general industrial subjects you can locate. These shots you could later sell to any photo buyer who needs to convey the *idea* of manufacturing.

Suppose you are a travel photographer on assignment to cover Naples, Italy, for a magazine. Keeping in mind the needs of your stock files, you should be careful to shoot extra film so that after the client has taken his or her pick, you will still have plenty of material to introduce into your stock files. The important thing is that you be constantly aware that your financial well-being depends upon your producing a continuing stream of salable stock photographs. Of course, your first responsibility when given an assignment is to fulfill that assignment to the very best of your ability, and therefore sometimes you will not be able to pursue all the stock possibilities you would like. But in most circumstances you will be able to obtain excellent stock shots easily without compromising in any way the quality of your assignment photographs. Stay on your toes and make the effort. By so doing in the long run you will greatly amplify the return you ultimately receive from your assignment work.

Shooting independent stock "assignments" • If you expect to earn a dependable, substantial income from stock photography, you should venture forth on your own initiative and at your own expense and shoot film specifically with stock—and only stock—in mind. Especially when you are first starting out as an assignment photographer and have more time than when your business is established, you should be giving yourself stock

Sometimes the careful application of good technique can make a simple photograph valuable. The slight soft-focus employed in this photograph elevates it from the commonplace and makes an art director feel that it has something special.

Be careful, however, that you do not apply techniques that cross the line into gimmickry. The technique you use should enhance the photograph without drawing attention away from its subject.

Since many products and services are marketed to families, typical family scenes have broad appeal in stock photographs. Those situations that tend to sell best involve families engaged in common, everyday pursuits.

Note in this photograph that the large neutral areas surrounding the main center of interest permit the photograph to be cropped into almost any shape that a layout might call for.

photography self-assignments. To be successful you must actively *pursue* your profession. In my experience, it is the photographer who is willing to get up at dawn to catch the sunrise who eventually makes big money in stock, not the photographer who proceeds casually along hoping salable scenes will miraculously appear.

Unquestionably, shooting stock specifically presents some obstacles: the high cost of film will be coming out of your own pocket, and you have no guarantee that the film you shoot will actually ever sell. The solution is not to give up before your start, but to maximize the marketability of each frame of film you shoot. Know what you are shooting; know what ideas you want to convey. If you see a situation that has possibilities, but it is high noon and the light is harsh, contrasty, and unappealing, do not settle for that shot; do not even expend film on it. Come back when the light is right. Remember: film may cost money, but you are *investing* that money in your

Frequently an art director will want to be able to surprint type on (that is, print on top of) a photograph. By composing your photographs so that they can accommodate surprinting easily, you increase their market appeal.

The large neutral areas in this photograph not only allow various cropping possibilities, but print set on top of the smooth blue color will be easy to read. In the photograph of the family on the previous page, the pattern of the leaves would make surprinting it difficult to read.

This is the type of photograph that could easily be taken at the end of an assignment shooting to augment one's stock files.

career. As is always true with investments, some pay off handsomely, some moderately, and some not at all. But if you risk nothing, you gain nothing, and the *only* way you will ever truly establish a solid income in stock photography is to shoot film continually and with a passion.

WHO OWNS THE PHOTOGRAPH?

If you shoot an assignment for a client, does the client own the photographs you take? The answer to that is emphatically no. Unless you have agreed otherwise in advance and in writing, you own the copyright on all photography you take, and you merely grant permission for the client to *reproduce* certain photographs for specific purposes. For ethical reasons you should never sell the photographs you took specifically for one client to another client, but photographs you take for your stock files while on an assignment are yours to use as you wish. You own the photographs and those that neither infringe on the good faith understanding the client had in hiring you nor invade his (or anyone else's) property rights can be included in your stock files.

This retention of rights holds especially with photographs used editorially. Generally, publications that hire you are entitled to North American publication rights only. You retain all the remaining world rights, as well as all rights to the other photographs you took at the same time as stock photographs.

Even still life photographs have great potential as stock photographs. Especially salable are photographs that relate to industry and technology.

This simple still life, composed only of a few bottles filled with colored water, has sold time and again over the course of years, mainly for use in annual reports.

HOW TO MARKET YOUR STOCK PHOTOGRAPHS ON YOUR OWN

If you are just launching your career in stock photography, probably the best way (if not the only way) you can market your existing shots is by personally contacting buyers and showing them what you have. The way to do this is essentially the same as marketing your portfolio for assignments. Locate the potential buyers, prepare a strong portfolio that will make a memorable impression, show art directors your stock portfolio, and periodically follow up with phone calls and/or flyers. Even if your initial attempts do not produce immediate sales, this personal method of marketing will help you acquire a knowledge of the marketplace that will stand you in good stead when it comes time to make arrangements with a rep or a stock agency.

HOW TO MARKET YOUR STOCK PHOTOGRAPHS THROUGH A REP

If you intend to actively pursue the stock end of your business, be sure that your rep is willing to both market your stock and do so energetically. Many reps are more than willing to handle a stock portfolio in addition to an assignment portfolio, but some prefer to concentrate on the assignment work and avoid pressing actively for stock sales. If that is the case, make other arrangements or your stock will languish.

Generally, a rep will want to take a greater financial percentage of your stock sales than of your assignment work. The rationale is that whereas the rep has to do as much work to make a stock sale as to line up an assignment, the photographer does not (since the shot already exists and no further work is required). Thus, while a rep takes 25 percent of assignment work, he or she might want to retain 35 percent or even 50 percent of stock sales. You must negotiate a mutually agreeable split with your rep.

In doing travel photography you should keep your eye out for good "key" shots that are immediately recognizable as having been taken at a particular place. However, because competition is fierce in travel photography, you must give your photographs something special to make them stand out.

Millions of photographers have photographed New York City, but most of the photographs look very much the same. These two are different, primarily because they say "New York" more succinctly and with more graphic power. It is no accident that both photographs were taken at dusk when the sky was still colorful or that a star filter was used in the photograph of the Statue of Liberty to add visual interest. Good travel photography requires patience, planning, imagination, and perseverence.

Although Yosemite Valley is one of the most popular tourist sites in the world, the photograph at left of Yosemite Falls has far less value in your stock files than the simple photograph of the sun and mountains in the above photo.

You need not spend vast amounts of money traveling to exotic locations. Study magazines and you will quickly learn to identify stock photographs and will develop an eye for situations that lend themselves well to the needs of the stock photography marketplace.

HOW TO MARKET YOUR STOCK PHOTOGRAPHS THROUGH A STOCK PHOTO AGENCY

Without question, most photographers who are serious about making money from their stock files eventually market their work through a stock photo agency. This is because the better agencies have developed extensive, worldwide marketing networks that can multiply many times over the size of the market that a photographer or his or her rep can tap into.

That's the good news. The bad news is that the agency will want to take 50 percent of the sale price of your material. Also, the competition among photographers who wish to be represented by the top agencies is fierce. You must be an accomplished photographer with a solid body of existing material before most agencies will be willing to represent you.

However, you can give yourself an advantage if you remember that while the agency is certainly interested in the material you have already shot, it is at least as interested—if not more interested—in the material you are *going* to shoot. That is, they know that their strength as a stock agency depends on the continual input of fresh material by the photographers they represent. If you can convince an agency that you are going to produce high-quality photography on a regular basis, the agency will often be more inclined to take you on than a photographer who initially has a larger body of work but who shows little likelihood of becoming a regular, dependable supplier.

CHOOSING A STOCK PHOTO AGENCY

Agency types • There are many agencies and many types of agencies. If you concentrate your efforts within a narrow area of photography, such as sports or wildlife or some other very specialized subject, specialty agencies may be best for you. Otherwise, you are probably best off with one of the general agencies that carry a

full range of photography, such as travel, mood scenics, florals, animals, industrial, and so on. There are many of these general agencies across the country, and as with most businesses, each has its own personality. Your goal should be to match your personality and the nature of your photography with those of the agency you ultimately sign with.

Contacting agencies • Do not be afraid to contact agencies. Look in the Yellow Pages of major cities to find the names of stock photo agencies. (Your local library will have copies of phone books from around the country.)

Establish initial contact with an agency by addressing a letter to the agency's general manager. Explain in your letter who you are, tell something about your professional background and the type of photography you shoot, and ask if you may submit a selection of your work for consideration. (Include a self-addressed, stamped envelope for the agency to use to reply.) *Never send photographs to an agency unless you have been instructed to, and always include return postage.* Unless otherwise instructed, submit only 35mm Kodachrome slides mounted in vinyl sheets (available from camera stores).

If, after seeing your work, an agency expresses an interest in representing you, exercise caution. Ask around about that agency. Talk to other photographers and ask them what they know about it. Contact local chapters of the ASMP (American Society of Magazine Photographers, headquarters: 205 Lexington Avenue, New York, NY 10016), and ask if anyone there is represented by that agency and what he or she thinks of it. Talk to clients. Have they heard of the agency? Used it?

Agency contracts • Is it possible to be cheated by a stock agency? In a word, yes. It is not likely to happen since most of the people at agencies are honest and honorable, but as with any industry where there are large sums of money involved, an unsavory element inevitably creeps in. Be careful. Most agencies will tie your material up for a long time, so it is in your best interests to make sure that the agency is reputable before you commit yourself. Read the ASMP guide to business practices.

Above all, if you are asked to sign a contract, make absolutely certain you thoroughly understand it. Remember: a contract does not mean what the agent *says* it means, but what a judge *decides* it means in a court of law. I strongly recommend that you *never* sign any contract without having it evaluated and explained to you by a lawyer you trust. The following are some contract provisions you may encounter that, in my opinion, you should *never* sign.

Never sign a contract that calls for automatic renewal at the agency's sole discretion—Some people, myself included, maintain that five years is an unreasonably long period for a stock photography contract to run, but five years is the time period used even by some of the most reputable agencies in the business. However, if buried in the fine print of such a contract you find a provision that permits the agency to renew the contract automatically, in effect that means you are making a ten-year commitment. My advice in such a circumstance: forget it.

Never sign a contract that appoints the agency your sole agent not only for the photographs you submit to it, but also for all photographs you have ever taken or will ever take while the contract is in effect—Do not sign a contract containing such a clause unless you are willing to surrender all control over your reputation, your talents, and your career for years and years to come.

Never sign a contract that does not spell out when and how often you will be paid or a contract that does not promise to give you at least enough sales information to permit you to police your photographs—That is fundamental information to which you are unarguably entitled. If an agency tells you that they will give you that information but that it just does not appear in the contract, refuse to sign unless the appropriate wording is added.

No matter how many assignments you shoot and how prominent an assignment photographer you become, the attention you pay to building your stock files over the course of your career will be like depositing money in a bank. Begin today learning everything you can about stock photography. The income you receive will be ample reward for the effort you expend. ■

EQUIPMENT

<div style="text-align:right">**8**</div>

Your camera and related equipment are as important to you as a brush is to a painter, a hammer is to a carpenter, or a scalpel is to a surgeon. Moreover, sometimes your ability to win a particular assignment will depend as much on the equipment you have as on the talent you show. We do not presume here to try to teach you photography, but we do want to make sure you are aware of some aspects of cameras and equipment that relate specifically to assignment photography.

CAMERAS AND CAMERA EQUIPMENT

35mm cameras • For many years art directors and printers insisted that the 35mm image was simply too small to withstand the rigors of enlargement. That bias has finally died, but only because of the exceptional image quality attainable with Kodachrome film. To this day, under many conditions the 35mm image *is* too small to use.

Are we suggesting that the 35mm camera has no place in commercial photography? Certainly not. The 35mm camera has fostered a "look" that has captured the imagination of art directors and the public alike. 35mm photography is here to stay, but if you are to use 35mm cameras successfully in completing commercial assignments, you must be careful to generate the best image possible (assuming, of course, that you do not *want* grain in your photographs). Here are some suggestions that you should follow to ensure that your 35mm work is acceptable to an art director.

Shoot only color transparency film—As will be discussed below, no black-and-white film can match the fine grain structure of Kodachrome color transparency film. If a commercial assignment calls for a black-and-white

image, you should use a larger-format camera. For editorial assignments, however, 35mm black-and-white images are often satisfactory.

Shoot to format—Anything you can do to reduce the amount of enlargement to which your photograph will be subjected will help preserve image quality. A poorly composed and framed image may require significantly more enlargement than one that has been designed properly. Study the art director's layout carefully, and then compose the scene you are photographing so that it has the same proportions as the photograph shown in the layout. Also, use as much of the film frame as you can.

For example, if the photograph will be cropped into a square, mentally impose a square frame over the scene in the viewfinder and use it to arrange the elements in the scene. If the image will be made into a two-page magazine spread, shoot with the camera held horizontally, and crop the image in the viewfinder exactly as it is cropped on the layout. (A 35mm frame oriented horizontally has almost exactly the same proportions as a typical two-page magazine spread.)

Use a strobe—Camera shake and subject movement are frequently occuring problems in 35mm photography. When you use a strobe, the duration of the flash and not the camera's shutter speed determine how much movement will be recorded on film. Since most strobes have flash durations shorter than 1/1500 sec., strobes contribute significantly to image quality. Of course, if you are shooting inanimate objects and can use a tripod, the strobe will offer no particular advantage with respect to image movement.

Maximize depth of field—Large out-of-focus areas in a photograph draw attention to the presence of grain. Use the brightest lights you can so that you can stop down your lenses as far as possible.

Focus critically—Check your focus carefully and often. Identify the most important component of your photograph and make certain that it is in sharpest focus. When working with models, the scene will appear sharpest if you focus on the model's nearer eye.

Medium-format cameras • Recent improvements in design have made some of the newer medium-format cameras (1¾″ × 2¼″, 2¼″ square, 6 × 4.5 cm., or 6 × 7 cm.) less clumsy than their older counterparts. Larger lens selections are available, and even through-the-lens metering and automatic exposure control have been introduced in some models. In addition, more brands are now available than just Hasselblad and Rolleiflex, which dominated the market for many years. Mamiya, for example, produces a high-quality medium-format camera at a reasonable price.

Whenever you are shooting in black-and-white, you will obtain a far better image with a medium-format camera than with a 35mm camera. In color, the two formats produce almost comparable images, although the medium-format size is more forgiving in the event your image proportions are off or you have not filled the frame completely. In addition, with a medium-format camera you use faster films than Kodachrome 25.

Large-format cameras • In general, the only fields of photography that usually require a large-format (4″ × 5″ or 8″ × 10″) camera are architecture, interiors, and still lifes. However, sometimes an art director will prefer a large-format image either because he or she harbors a bias against the smaller formats or because the large image is easier to retouch.

The real impact of large-format cameras on image quality can be shown by comparing enlargements. You must enlarge a 35mm negative 240 times to make a 16″ × 20″ print, whereas an 8″ × 10″ negative need be enlarged only 4 times. In addition, large-format cameras allow you to control perspective in ways that are impossible with other types of cameras.

Unless you specialize in interiors or still lifes, you probably do not need to own a large-format camera. However, to be able to handle the occasional asssignment where a large-format camera is required, you may want to borrow or rent one to become familiar with it.

Large-format cameras have some distinct disadvantages. They are so large that they always require a

tripod. Also, film is expensive, and the process of taking a large-format photograph is both slow and tedious. Nonetheless, if you know how to use a large-format equipment, you may be able to attract and accept jobs that other photographers will have to pass up.

Camera brands • You cannot expect to obtain professional-quality results without professional-quality equipment. You will pay more in the short run, but you will be rewarded with satisfied clients. Moreover, the better the quality of the equipment you buy, the more value it will retain over the years. Without question, you should be accumulating the best equipment you can.

Polaroid camera backs • When you execute an assignment, the art director is depending on you to deliver usable photographs. Prudence and professionalism demand that you do anything you can to help ensure the success of a shooting.

For years Polaroid backs have been available for medium- and large-format cameras, and recently a Polaroid back designed to fit a 35mm Nikon body was announced. The value of the Polaroid photograph lies in the immediate information it provides. Before the advent of the Polaroid back, photographers never really knew if everything was in order during a shooting until the film had been processed. In the case of Kodachrome, this meant a wait of at least twelve hours and usually longer. With a Polaroid back you can set up your shot, affix the back to the camera, and take a test exposure (making certain, of course, to compensate for any differences between the ISO of the Polaroid film and that of the film you will be using to take the actual shot).

Within seconds you will be able to verify your exposure settings and make certain that everything in the frame is in satisfactory order. A defective camera will be immediately apparent, and you will be able to detect such careless errors as an incorrectly set shutter speed. In short, using a Polaroid back whenever you can will go a long way toward helping you avoid and solve unexpected problems before they can destroy your shooting.

FILM

We have already touched upon film under the discussion of cameras. Here, we will summarize and discuss some additional aspects.

Color film • For assignments that require color images, you will almost invariably be expected to shoot color transparency film rather than negative film. The reason is simply that art directors are accustomed to working with transparencies, which are relatively easy to retouch. As already mentioned, in 35mm no film can match Kodachrome 25 for sharpness. Indeed, with any other color film, the image must be shot on a medium-format camera to produce enlargements with a level of quality comparable to that of Kodachrome.

Black-and-white films and prints • We must reemphasize that for most applications 35mm black-and-white film is not adequate. If you have a black-and-white assignment, use a medium-format camera.

The differences among the various black-and-white films are not nearly as great as among color films. Therefore, the specific brand of film you use is mostly a matter of how much contrast you want. The choice is up to you.

You never submit black-and-white film directly to the client. Instead, you provide contact prints and enlarge an image or images according to his or her instructions. Since prints are frequently retouched, you should, if at all possible, submit prints large enough so that they will be reduced in their ultimate usage. This will make the print easier for retouchers to work with.

When you make the print for the client, treat your work with respect. Use high-quality printing paper, and center the image so that the borders around it are even.

OBTAINING EQUIPMENT

New or used? • If you have the money to buy high-quality, new equipment, you pay more, but you avoid being saddled with someone else's problems. However, do not sacrifice quality for the sake of newness. Better to use old equipment that will render a good image than new equipment of inferior quality.

Basic 35mm Rangefinder System

This system consists of two bodies, a 21mm super wide-angle lens, a 35mm intermediate wide-angle lens, a 50mm normal lens, a 90mm portrait lens, and a high-quality hand-held light meter. The system is light, compact, and quiet, and would be excellent for a photojournalist to build on. The Leica brand camera is the most rugged and dependable rangefinder camera made, but it is also the most expensive.

Used photographic equipment is widely available. Usually, your best source is a store that sells used equipment and provides a warranty. You will pay more than for comparable equipment sold privately, but at least you will be protected from buying something that turns out to be defective.

One of the greatest advantages of buying used equipment is its resale value. When you buy new, you are lucky if you can later sell your equipment for half of what you paid for it. With high-quality used equipment, your purchases usually retain their value for years and sometimes actually appreciate. Thus, by starting out with high-quality used equipment, you can trade in the equipment for full value and replace it with new equipment when you can afford the difference in price.

Rental equipment • The option to rent enables you to take on jobs that you would not otherwise be equipped to handle. Normally, any items of photographic equipment that you must rent come out of your fee, but if the item is really unusual (a 2000mm lens, for example), sometimes you can pass the rental fee onto the client. Remember, though, that the client may have been attracted to you *because* you have the equipment, and therefore you may be wise not to let him or her know that you rented the item.

Whenever you rent equipment, test it thoroughly before using it on an assignment. You never know if the item was abused by the last renter. The best attitude is to assume that the item is defective and then set out to identify the defect. On an important assignment you may need to rent the item a day in advance of the shooting to allow time for the test.

ACCESSORIES

For other camera accessories, the same rule of thumb applies: buy the best you can afford. Tripods, filters, gadget bags—all are sold in a variety of qualities. Identify the top brands, and then choose among them on the basis of your personal preferences. You simply cannot afford to allow your equipment to undermine the quality of your work. ■

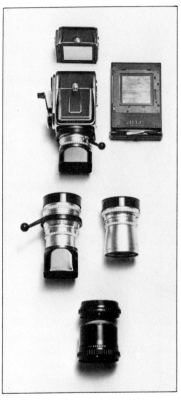

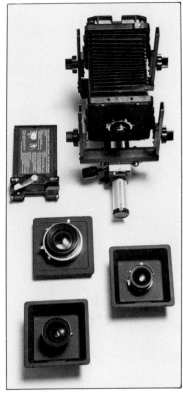

Basic 35mm SLR System

This system consists of two bodies (one with an optional motor drive), a 20mm super wide-angle lens, a 35mm intermediate wide-angle lens, a 55mm normal/macro lens, an 80–200mm zoom lens, and a 400mm telephoto lens. This is an extremely versatile system that will be sufficient for the vast majority of the 35mm assignments you might be given.

Basic 2¼" Square System

This system consists of a single body with two interchangeable film backs, a Polaroid back, a 60mm wide-angle lens, an 85mm normal lens, a 150mm portrait lens, and extension tubes for close-up photography. The system is excellent both for studio assignments and for location shots. A system such as this meets only the minimum requirements for a photographer who must do fine black-and-white photography. The Polaroid back permits on-the-spot evaluation of lighting and exposure.

Basic 4" × 5" Studio View Camera System

This system consists of the camera body, a Polaroid back, a 75mm very wide-angle lens, a 90mm intermediate wide-angle lens, a 135mm normal lens, and a 240mm long/normal lens. The specific lenses to purchase depend very much on the type of photography for which the camera will most commonly be used.

Considering that many photographers own more than one of the systems shown on these two pages, the initial investment involved in an assignment photography business can be considerable. All told, the equipment shown here is worth more than $10,000 new, although the price would be substantially lower for used equipment.

LIGHTING EQUIPMENT

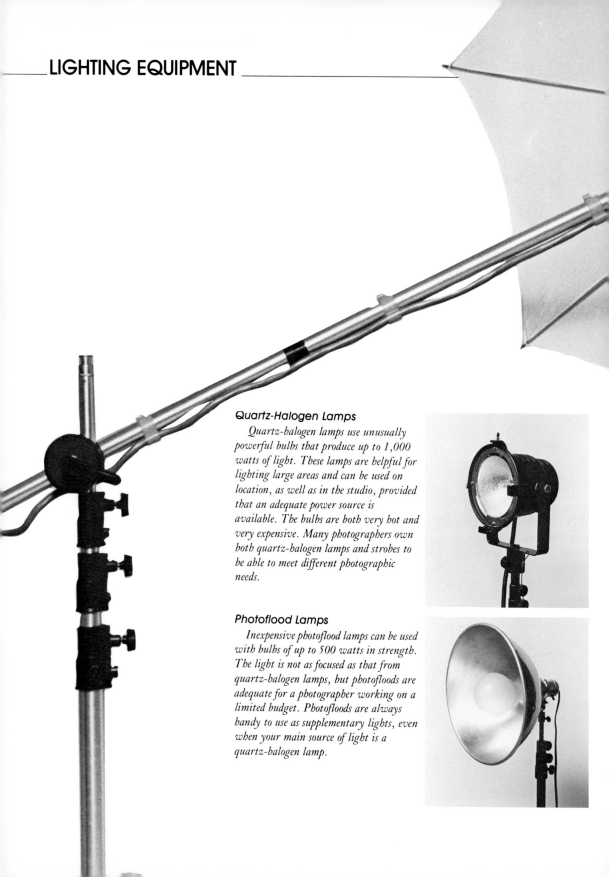

Quartz-Halogen Lamps

Quartz-halogen lamps use unusually powerful bulbs that produce up to 1,000 watts of light. These lamps are helpful for lighting large areas and can be used on location, as well as in the studio, provided that an adequate power source is available. The bulbs are both very hot and very expensive. Many photographers own both quartz-halogen lamps and strobes to be able to meet different photographic needs.

Photoflood Lamps

Inexpensive photoflood lamps can be used with bulbs of up to 500 watts in strength. The light is not as focused as that from quartz-halogen lamps, but photofloods are adequate for a photographer working on a limited budget. Photofloods are always handy to use as supplementary lights, even when your main source of light is a quartz-halogen lamp.

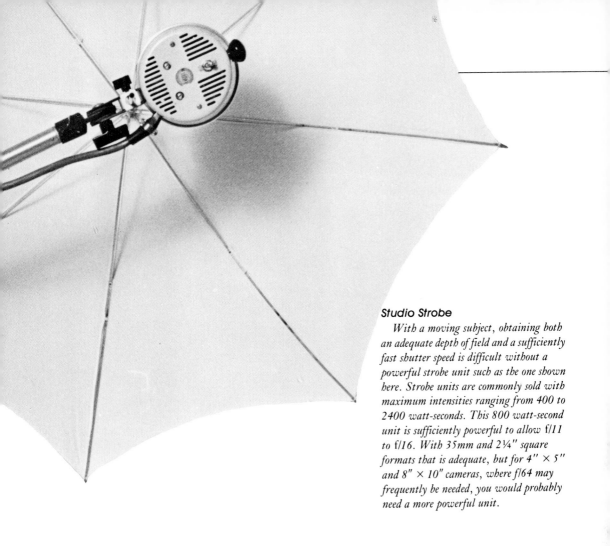

Studio Strobe

With a moving subject, obtaining both an adequate depth of field and a sufficiently fast shutter speed is difficult without a powerful strobe unit such as the one shown here. Strobe units are commonly sold with maximum intensities ranging from 400 to 2400 watt-seconds. This 800 watt-second unit is sufficiently powerful to allow f/11 to f/16. With 35mm and 2¼" square formats that is adequate, but for 4" × 5" and 8" × 10" cameras, where f/64 may frequently be needed, you would probably need a more powerful unit.

Lighting Accessories

Strobes and lamps alone are not sufficient to give you complete control over your light source. You also need the items shown here: stands of various sizes, clamps, umbrellas, reflectors, and heavy-duty extension cords. The cost of lighting equipment can mount quickly and can easily run into thousands of dollars.

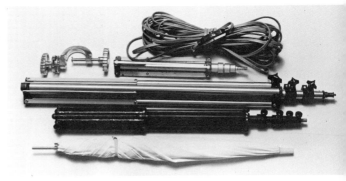

THE STUDIO

9

Some photographic specialties, such as still life and illustration photography, regularly require the use of a studio. Other specialties, such as photojournalism and architectural photography, rarely do. Nonetheless, no matter what your specialty, at one time or another you will probably need to use a studio for an assignment. Therefore, you should be familiar enough with studios so that if the need arises you can handle a shooting confidently and competently.

LONG-TERM LEASES VERSUS SHORT-TERM RENTALS

Studios are available either for rent under a lease or for day-by-day rental. Which route you choose will depend on a variety of factors.

The number and size of your studio assignments
• Obviously, if your income from assignments is minimal, it will make little sense to incur the continuing expense involved in renting under a lease. However, even if you earn a substantial amount of money from studio shootings, unless you will be shooting in the studio at least once per week, chances are you will be financially better off renting space day by day.

Having your own studio is more important if your studio assignments tend to be frequent—even if your fee for each shot is relatively small. For example, if a substantial amount of your work involves catalog shots, the benefits of being able to work in the same space day after day will outweigh the cost of leaving the space occasionally idle.

The decision is most difficult when the type of work you do falls between the extremes: when you have a moderate number of studio assignments (one every ten days to two weeks) for which you are able to charge only moderate fees ($300 to $400 per shot). Under such condi-

tions the decision to lease or rent short term must be partly based on the factors discussed below as well.

The value of having your own space • Without question, you will be much more comfortable in a studio that you feel is your own. You will be familiar with the layout, the equipment, the lighting characteristics, and any idiosyncracies of the studio that might affect a shot. You will have a supply of useful props and backgrounds on hand and will not need to carry them with you to a strange studio. You will be able to build sets well in advance of a shooting, if you wish, and leave them up until you have had a chance to inspect the film.

Equipment reliability • Rented equipment is notoriously unreliable. Although you could bring all your own lights and other items you need with you to a rented studio for a day's shooting, often it is more convenient to use the equipment that is already on hand. Unfortunately, unless you have time to run a test on the equipment in advance of the actual shooting, you will not know how reliable it is.

LEASING A STUDIO

Agents • Some brokers specialize in finding commercial rental space. If you can find someone trustworthy, that person can take care of much of the legwork involved in finding space and render much valuable advice. Since the landlord pays the agent's fee, there is no financial advantage to your trying to find the space on your own. (An exception may occur when you sublease from an existing tenant, in which case you may be required to pay the agent's fee yourself.)

Use the Yellow Pages to find the names of real estate agents specializing in rental properties. Call a few agents and meet with them. Ask questions, and select the one most knowledgeable about the needs of photographers.

Raw space • Because you will not have to work around or move existing partitions, "raw," unimproved space will be easier to adapt to photographic use than space that has previously been used as offices. Moreover, if you will need to perform a substantial amount of work

yourself to make the space usable, you can often negotiate a rent reduction.

Subleasing • One of the best ways to obtain usable studio space with a minimum of effort is to take over a studio from a photographer whose lease has expired or to sublease from a photographer who is vacating before the lease expires. You may have to pay more than for raw space, but you will have far less work to do to bring your studio into full operation.

Size requirements • The amount of space you should lease is, of course, limited by the amount of money you can afford to pay, but for the sake of discussion, let us assume that you are able to pay as much as necessary to acquire the space you need.

Photography often requires less space than you might imagine. Of course, if you specialize in photographing automobiles or other large objects you will need a huge room to work in, but for fashion, illustration, small still lifes, and most catalog work, you should be able to handle most, if not all, of your assignments in a medium-size room of 1,000 to 1,500 square feet (100 to 150 square meters). If your work is primarily limited to small still lifes, 500 to 1,000 square feet (50 to 100 square meters) may be adequate.

To a great extent the usefulness of a given room depends on its shape. Since a rectangular room allows you to move farther from your subject than a square room with the same floor space, a rectangular room will be more useful for most shots.

When looking for space to lease, do not trust the figures provided by the landlord. Some landlords seem to have difficulty measuring accurately, and some even include the elevator and stairwell in their measurements.

Before you lease a particular studio, inspect it through a camera. Make certain that the dimensions of the room allow you to use the lenses you are most likely to need. If the room contains any pillars, be sure that you can work around them. If you will be shooting with models, visualize where you will set up a changing area. Do not overlook the space you will need for a desk and for equipment storage. Establish that the bathroom facilities are adequate.

Elevators • One of the most important aspects of leasing studio space is determining that the elevator is large enough to meet your needs (unless the studio is on the ground floor). Make sure that the elevator can accommodate the largest items you expect to be photographing in your studio. Few experiences are more embarrassing than having to change the location of a shooting at the last minute because your elevator cannot accommodate the item you are being paid to photograph.

Also, inspect the approaches to the elevator. Sometimes its effective size will be reduced by the presence of sharp corners or narrow approach corridors.

Ceilings • High ceilings are usually desirable because they allow you to shoot down on objects from above. Most photographers find 12-foot ceilings adequately high, but you must select a height on the basis of your own requirements. If you will be doing only table-top still life photography, you will probably be able to work under ceilings lower than 12 feet.

Windows • Windows are more than a convenience. If you want to have the option of using available window light, they should be large and placed where they are easily accessible. If you usually shoot using tungsten light, however, you may prefer a studio with small windows that are easy to block.

One disadvantage of window light is that it can deceive a client who is not accustomed to working with strobes. Because the client does not realize that the window light falling on a scene will be overwhelmed by the strobe light, what he sees with his eyes is not necessarily what will appear on film.

Darkroom • If you expect to do much black-and-white photography, be sure when you are selecting space to allow for the area the darkroom will occupy. Find out where the water pipes are located and estimate the cost of any work you will need to have performed by a plumber. If you are lucky, you will be able to find a studio with two bathrooms, one of which can be converted into a darkroom.

Security • Over the years you will accumulate and need to store a large amount of valuable equipment in

your studio. As a result, especially in large cities, your studio will be a prime target for burglars. Therefore, before signing a lease, you should convince yourself that you can adequately protect your belongings. No studio can be made completely secure, but at least check to see that doors and walls are solid and that the building's entrance is locked at night. If the studio is on the ground floor, you will probably need to invest in metal grates to cover the windows. On other floors you will need metal gates to cover fire escape windows.

Once you are settled into a studio, do not leave valuable equipment lying about. During a shooting, bring out only the camera equipment you actually need. Create hiding places in various locations so that you do not have to store your most expensive equipment all in one place. Experienced burglars will probably find everything, but your foresight may outsmart an amateur. Be sure to keep your insurance up to date.

Utilities • You can prepare a rough estimate of your electrical needs by adding up the rated wattage of all the items you might be using at one time. Do not overlook any substantial item, including not only your photographic lights, but also any of the following items you might have: refrigerator, oven, coffee maker, fan, air conditioner, iron, hair dryer, and hot curlers. Divide the total wattage by the electrical voltage (110 volts in the United States). The result is the maximum current drain in amps that your circuitry must be able to handle at one time. Make sure that the current will not exceed the rating of the fuse of the circuit breaker for that circuit. If you have more than one circuit (and for safety's sake, you should), you may be able to distribute the current drain among the circuits by connecting your equipment to different outlets via extension cords.

Other utilities such as water and gas do not usually affect your decision to lease.

Color • Only white, black, and gray are acceptable colors for a studio. Light reflected off any other colors will have an affect on color film. White, being highly reflective, has the advantage of increasing lighting efficiency, but many paints labelled "white" actually contain

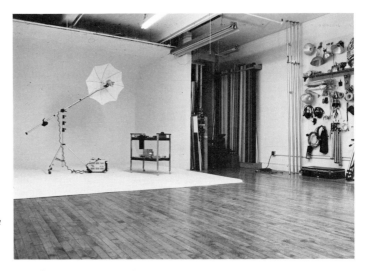

Some photographers construct a "cyclorama" in their studios, such as the one shown on the left side of the photograph at right. A cyclorama consists of a small room in which the joints connecting the floor and ceiling to the back wall have been smoothed into gentle curves. Objects photographed in a cyclorama appear to float in midair. You can achieve the same effect with seamless paper (rolls of which are shown standing on end in the photo), but with less convenience. In addition, with its wall painted white, a cyclorama efficiently reflects and concentrates light.

The cart shown in front of the cyclorama is convenient to use during shootings for holding extra cameras, film, lenses, filters, and other accessories. Note that the equipment stored on the wall is neatly organized both to make a favorable impression on clients and to increase efficiency during shootings.

small quantities of colored pigments. Usually, paints labelled "ceiling white" are pure enough for photographic work. Sometimes, the landlord will agree to do the painting before you move in.

Startup expenses • In addition to the expenses you may have to incur that have already been mentioned, there are other startup expenses you may have to meet.

Attorney's Fee—Standard leases contain many clauses unfair to the tenant. Without exception, any lease you sign should be reviewed by an attorney *experienced in real estate law.* Some clauses landlords will strike without argument; other clauses are negotiable. The law is so complex, the amount of money involved is so great, and the consequences of signing a bad lease are so severe that you cannot afford to bypass an attorney. If you can afford the fee, have the attorney do the negotiating for you.

Security Deposit—Invariably, you will be required to pay between one month's and three months' rent to the landlord as security against your damaging the property or failing to make the agreed-upon rental payments. Try to have this money placed in an escrow account from which you at least receive the interest.

Furniture—As a minimum you will need to furnish your studio with a desk, chairs, file cabinet, and lamps. In addition, you may want to consider a rug (for the nonshooting areas), couch, table, and refrigerator.

Office Supplies—All the paraphernalia associated with running a business must be purchased: paper, pencils and pens, paper clips, stamps, envelopes, etc. You will find that office supplies are a constant drain on your bank account.

Darkroom—Unless you shoot color film exclusively, you will probably need to install a darkroom. How elaborate your setup should be depends on the type and quantity of work you do. As a minimum, you will need developing tanks, reels, and trays, an enlarger, chemicals, paper, a safelight, a darkroom sink, a timer, a thermometer, and measuring and storage containers. If you are taking over a studio that is already being used for photography, you may be able to purchase the equipment you need from the previous tenant.

Running expenses • There are many hidden costs associated with running a studio that you should take into consideration when calculating your ability to afford to lease a studio.

Commercial Occupancy Taxes—Some municipalities impose taxes on the rent commercial enterprises pay. In New York City, for example, a business is required to pay a tax of anywhere from 2½ percent to 7½ percent, depending on the amount of the annual rent.

Electricity—Obviously, the more electricity you use, the more it will cost you. Photographic lighting equipment alone is expensive to run, and during shootings you may also need to use an air conditioner (you cannot afford to have sweating models), one or more ovens (if you are taking food shots), electric curlers (for quick hairstylings), and an iron (for preparing clothes). Estimating your expenses in advance is difficult.

Telephone—Phone installation can be expensive, but do not overlook the continuing monthly expenses involved. In general, you will need at least two extensions, one near the shooting area and one on your desk.

Assistant—When you are first starting out, you will probably be able to manage the studio yourself. When work becomes plentiful, however, you may need to place an assistant on salary to manage the studio for you. This will free you to concentrate on shooting.

Receptionist or Guy/Gal Friday—If you are lucky, you will be able to find someone with multiple talents and interests who will perform a whole range of functions. The ideal person would answer the phones, perform secretarial tasks, and also assist during shootings and in preparing for them. Such multitalented, industrious people are difficult to find.

Insurance—As you accumulate more and more equipment, the cost of insurance coverage will escalate. In addition, the cost of liability coverage is higher if you sometimes photograph models.

Refuse Collection—The cost of commercial refuse collection is substantially higher than that of residential collection. Moreover, in many localities refuse collectors enjoy monopolies, with the result that no alternative exists to fees that are held artificially high.

Gratuities—Gratuities constitute a significant but often overlooked studio expense. Each year during the holiday season you are likely to find people you have never seen before—refuse collectors, for example—stopping by to wish you a "Merry Christmas" or "Happy Hanukkah." If you expect services to be rendered reliably, you will probably need to offer these people some holiday cheer (cash only—they will not accept checks).

In addition, in many localities certain public officials and inspectors will expect you to reward them for doing their jobs. Protocols vary and the matter is ticklish, but be sensitive to broad hints. Whether you actually extend these gratuities is a matter for you to decide, but remember that these people generally have broad and almost uncontestable authority over you—and will be willing to use it against you if you are not "cooperative."

Of course, it is perfectly appropriate to express your thanks with money to people who are helpful. In particular, you should not forget your building's superintendent. Usually, a generous gift at holiday time will be appreciated and returned in the form of conscientious service throughout the year.

Leasing a studio is a major undertaking, but one that can be important to your career. Be careful before you make a commitment.

RENTING STUDIO SPACE DAY BY DAY

Aside from not contributing to a high overhead, day-to-day rentals have the advantage of allowing you to fit the studio to the job. For example, if you need daylight to shoot, you can rent a studio with large windows. If you need to take long exposures, you can rent a studio in which the windows can be easily blocked.

Most studios rent for a full day, but some will allow you to rent for only a half day. The equipment that is included in the rental fee varies from studio to studio and is negotiable.

The following are some hints that will help make studio rentals go smoothly for you.

Identify a few good studios • Studios, like people, are widely diverse. Moreover, a studio is only as good as the photographer who runs it. Inspect as many studios as you can in your area *before* you actually need to use one. Identify the few that you like best. Eventually, on the basis of experience, you will be able to settle on the two or three that best meet your needs, and use them again and again. In this manner you will become accustomed to the individual setups and will be able to work efficiently in them.

Plan your shootings carefully • When you are paying by the day for space, you cannot afford to be inefficient. Each shot must be thoroughly organized in advance, and you must determine accurately what you will need to bring along. If you are not in and out on time, you will be charged extra. For each shooting prepare a checklist of equipment and props to bring along, and follow it. If you regularly shoot out of rented studios, maintain a trunk filled with basic equipment that you need every time.

Whether you lease your own studio or rent day by day, your ability to shoot in a studio will win work for you that other photographers would have to turn down.■

SHOOTING ON LOCATION

10

Shooting on location—that is, anywhere other than in a studio—often conjures up mental images of glamorous trips to exotic Carribean islands with an entourage of art directors, models, stylists, and miscellaneous assistants. While such exotic location shootings certainly do occur, far more often the location is mundane or just around the corner. Indeed, a location shooting may mean nothing more grand than moving a few steps into a local park. As a result, location shootings constitute a major portion of many photographers' assignments.

Many location shootings involve only you and perhaps an assistant. For example, you may be asked to photograph a factory and its workers for an annual report. For the sake of thoroughness, in this chapter we will discuss complicated shootings in which many people are involved. Especially when you are first starting out, most of your location shootings will probably be local and relatively simple. However, the same basic principles apply to any location shooting.

The primary concern in any location shooting is that no problems arise that cannot be dealt with on the spot. In a studio it is easy to have so many supplies on hand that no matter what happens, you have a solution or an alternative available. On location an entire shooting could fail simply for want of a simple—but forgotten—item of equipment (a synch chord, for example). Thus, the key to successful location shootings is thorough planning and preparation for all contingencies.

PREPARE A GENERAL CHECKLIST

Airline pilots know by training every move they must make to get a plane in the air, yet by law they must

follow checklists as a way of ensuring that they have overlooked nothing. Following a checklist is equally important for you when preparing for a location shooting.

Checklists perform two functions. The act of making up a checklist helps you think through the assignment and brings to mind any areas where you are unclear about what you will need to do. And then performing the operations dictated by the checklist guarantees that you do not forget to do and to bring everything as planned.

You really need a standard checklist that you go over before *any* location shooting and a second checklist that you prepare on the basis of the individual requirements of each assignment. Each checklist should be reviewed twice: once as a guide to follow while assembling everything you need and again just before you leave to make certain that you have left nothing behind.

When drawing up your checklists, keep in mind the principle of redundancy. Every critical item of equipment should have some form of backup. Cameras, essential lights, batteries—anything at all that absolutely must function properly for the shooting to be a success—must be supported by a backup. Not to do so invites disaster.

QUESTION THE CLIENT CLOSELY

In order to be fully prepared you must know exactly what the client wants and what he or she expects you to do. Ask as many questions as necessary to clarify your role and the shot's requirements. Find out exactly what the shot entails and what props you will be expected to provide. Who will go along? How much time will be allocated?

Will it be necessary to arrange in advance for any special facilities? Has the location already been selected? If not, whose responsibility is it to perform the search?

Overlook nothing that could have a bearing on the shot. If the location is distant, you will have to determine what to bring with you and what is better obtained in the vicinity of the shooting site.

SETTLE FINANCIAL MATTERS
EARLY

Your fee • As always, your fee is negotiable, and you must decide how large the payment must be to make the shooting worth your while. For the actual shooting day (or days) you should receive either your day rate or a higher amount based upon the way the photograph will be used (see Chapter 6). For time you spend on location searches and for travel days the standard is half the normal day rate, but if in order to execute the assignment you will have to turn down other jobs, you can insist on your full-day rate.

Expenses • Even a local one-day shooting usually costs more than a studio shooting, and expenses mount especially quickly in shootings that involve overnight stays. Therefore, before you agree to take on a location shooting, you must clarify who pays for what and determine that you have the cash necessary to meet your end of the expenses. Unfortunately, no standard policy has ever been developed to deal with the question of who is responsible for carrying which expenses involved in a location shooting.

The problem, of course, is that although you will be reimbursed eventually for out-of-pocket payments, it may be months before you receive the money. Location shootings are an example of the importance of monitoring cash flow. No matter how high the fee you will ultimately receive, if the job drains so much cash from your business that while you are waiting for reimbursement you cannot meet your day-to-day expenses, then you may not be able to take the job.

Generally, the major expenses you must absorb are for transportation, lodging, and meals for you and your assistant and occasionally for the cost of using the location, if it is privately owned. Fortunately, there are some strategies you can follow that will enable you to minimize the out-of-pocket expenses you will have to carry.

By discussing the matter well in advance of the shooting, you can often arrange for the ad agency to pick up most of the expenses. For shootings that require plane

travel, if the client works for a company large enough to have its own travel department, you should ask the art director to have your ticket drawn up along with his or hers. If you are responsible for arranging everyone's transportation yourself, you can try to have all of the tickets paid for by the agency.

You are not normally required to pay any hotel expenses except your own, but remind the art director that he or she must be able to make the required payments before checking out of the hotel. Otherwise, you may have to pay for it yourself. One technique is to call ahead well in advance and make arrangements for the hotel to accept a check from your client's company. As long as the art director remembers to bring along the check, you will not have to cover any of the lodging and meal expenses that are included on the hotel bill.

For any expenses you have to cover yourself, use charge cards so that you can delay payment as long as possible.

OBTAIN A PURCHASE ORDER

So much time and money can be involved in a location shooting that to protect yourself you should insist on a purchase order outlining your obligations. In addition, you should send a letter in which you specify your understanding of what you are supposed to do, your fee, what you are responsible for, and what the client is responsible for. The purchase order constitutes a contract between you and the client, and your letter clarifies the conditions of the contract. (If the company does not issue purchase orders, your letter may constitute the only written record of the terms under which the shooting takes place.)

SELECT THE LOCATION

Location searches are an inconvenience that you often cannot avoid. Some clients will want to find their own location, but many will want you to do it for them. When the shooting will be far away, often the client will indicate the general region in which he or she wants to shoot, but you will have to select a specific site.

If the location is to be within a few minutes of your home base, you can perform the search yourself, if you have time. When the search is likely to be extensive and time consuming (for example, if you needed to find a house containing a particular type of colonial fireplace), you should send someone to do the looking for you. Sometimes a reliable photographic assistant can handle the job, or in the larger cities, you can often engage a professional search service to find the location you need. Many of these services maintain a cross-referenced file of locations suitable for photography. The better-organized firms also have photographs of the locations on file. You can find the names of location search services in the Yellow Pages or from *The Madison Avenue Handbook* (see Bibliography).

No matter whether you find the location yourself, send an assistant, or hire a firm, always have Polaroid photographs taken of the site. If you have not seen the site yourself, the photographs will enable you to evaluate it. But even for locations you have visited yourself, the photographs will be valuable for reference.

LEARN ALL YOU CAN ABOUT THE LOCATION AND ITS ENVIRONS

Every city and many towns have a Chamber of Commerce that exists specifically to promote the business interests of the community. While the person answering the phones probably will not know much about photography, you should be able to obtain answers to questions about what kind of stores are available, the local climate and terrain, and anything else that a local resident would be likely to know.

The elements that make up a still photography shooting have much in common with a movie shooting. Since having a movie crew visit a town guarantees that a large amount of business will be generated for local establishments, most states and some cities, as well as many foreign countries, have a government-sponsored board that exists specifically to act as a liaison between movie makers and photographers and the local community. You will find the people on these boards very helpful.

A good source for the names and addresses of these boards—as well as many other services and resources related to photography—is the book, *On Location* (Consolidated Publishing, Inc., 6311 Romanie, Hollywood, CA 90038). Intended primarily to aid in the production of movies, the book is equally valuable to the still photographer.

DECIDE WHAT TO BRING AND WHAT TO OBTAIN LOCALLY

For one-day shootings and those in which little traveling is involved, most items needed for a shooting can be transported from home. However, when long distances and bulky or perishable props are involved, you may want to obtain them locally after you arrive on location. Call ahead if you are not sure that the item will be available, however, or if it must be reserved in advance.

If at all possible, bring along with you anything that is absolutely critical to the success of the shooting. Even if you have called ahead and confirmed that what you need will be available, unexpected problems can arise. If you do depend on local procurement of a critical item, be sure to have some alternate plan that you can implement in the event that the unexpected occurs.

ARRANGE ACCOMMODATIONS

You may be expected to make the hotel arrangements for everyone involved in a shooting that will run more than a single day. In doing so, coordinate arrivals and departures so that the people involved in the shooting are incurring expenses only during periods when their presence is actually required.

Because of the high fees they receive, models especially should be scheduled tightly. Given the speed of modern transportation, it is not unreasonable to fly a model a thousand miles or more in the morning, shoot for six hours, and then have him or her catch a return flight the same day. In this manner you both contain the size of the model's fees and eliminate the meal and lodging costs involved in an overnight stay.

Before you book reservations at a given hotel, make certain that the charges fit within the client's budget.

CHECK THE WEATHER

If for any reason the weather will affect the shot, start checking the forecasts well in advance of your planned departure date. The best source of weather information is the National Weather Service, which has stations located throughout the country. Simply call Information in the area where you will be shooting and ask for the nearest Weather Service office. Often, the phone number you are given will connect you with a tape recording, but the recording will provide another number you can call to obtain further information. Be sure to establish contingency plans to follow in the event of bad weather.

Other sources of weather information are National Parks located in the region in which you will be shooting. Locate the nearest National Park facility and call visitor information. The person you talk to will be knowledgeable and extremely helpful.

MAKE PROVISIONS FOR CONTACTING PEOPLE BACK AT YOUR HOME BASE

Sometimes, you will need to depart in advance of anyone else in order to initiate needed on-location preparations. Before you go, be sure to obtain the phone numbers—home as well as business—of everyone who will be coming later. You never know when you will need to call someone late at night or on a weekend to announce a change in plans or to ask for help in solving some problem that has arisen.

Finally, make sure you have a contact person at your home base who is prepared to help out if you call. You cannot anticipate every eventuality that might develop during a location shooting, but the contact person will help ensure that you have a means available for dealing with the unexpected.

DOUBLE-CHECK EVERYTHING
BEFORE DEPARTURE

Go over your checklists again immediately before you depart. You do not have to inspect every single item visually, but use the list to confirm that you remember packing each of the items listed. Double-check individual items that are critical to the shooting. While you are going through the checklists, you can also be evaluating the way equipment is packed to make sure that fragile items are adequately cushioned.

Film especially should be protected. Although the airlines insist that their X-ray equipment does not harm film, many photographers have reported trouble with fogging. The problem is particularly likely to occur with film that has passed through security devices more than once. Lead bags are sold to protect film, but an easier method is simply to carry your film in a plastic bag that you can remove from your camera bag and handcarry around the X-ray device. If the plastic is clear, inspection personnel will pass you through without delay.

SCOUT THE LOCATION

If you do not already know exactly where you will be shooting, as soon as you arrive (or as soon as you have checked into your hotel, if an overnight stay is involved) you should find the exact location you will want to use and inspect it to determine if there will be any problems that must be addressed before the shooting can begin. Should the shooting involve the sea, do not forget that the appearance of a beach will change with the ebb and flow of the tide.

SHOOT EXTENSIVELY AND
PRUDENTLY

Even more than in studio shootings, you have an obligation to make certain that by the time you leave the location, you have some usable images on film. As we have already suggested, if possible, check the shot with a Polaroid camera; shoot on at least two camera bodies;

bracket your shots widely; and shoot more film than you think you need. Neither you nor your client can afford to repeat the shooting for want of a usable image.

As you are shooting, for safety's sake place every other roll of film in one of two different containers. In this manner some exposures from each scene or pose will be in two storage locations.

Even if conditions are such that at the last minute you must deviate completely from the original plan, remember that everyone present is being paid and expects to work. If the weather suddenly turns bad, try to move the shot indoors or under some sort of open shelter. Perhaps you can shoot at dusk or at night, when a cloud-filled sky will not be apparent in the photograph. If you are successful and have to reshoot later anyway, nothing will have been lost; but if your resourcefulness makes a reshoot unnecessary, you will have done what you were being paid to do and will be a hero, to boot.

DURING THE RETURN TRIP, PROTECT YOUR FILM

After the shooting nothing is more important than the exposed film. Keep it with you at all times, but not all in one place. You could keep half in your camera bag and half in an airline bag or one held by your assistant. Again, do not allow the film to go through X-ray machines and handcarry the bags containing the film throughout the entire trip.

PROCESS AND DELIVER THE FILM AS QUICKLY AS POSSIBLE

When you arrive home, send the film out as soon as you can, half at a time if you want to be particularly cautious. When the film is returned to you, edit it quickly (as described in Chapter 6) and then forward it to the art director immediately.

Location shootings are challenging, yet often exciting and rewarding. No matter how small the job, if you follow the general principles we have described in this chapter, you should be able to take location shootings in stride. ■

SUPPLIES & SUPPLIERS

11

Because of the large amount of money involved in commercial photography, a variety of professions have sprung up to support the efforts of photographers. If you choose the right support people to assist you in a shooting, you will be left free to concentrate on photography, while your suppliers can assume responsibility for the rest. You will have to oversee their work (after all, you are ultimately in charge), but if the people you choose are skilled, you can rely on their advice and judgment to a great degree.

The suppliers described in this chapter are mainly to be found in the larger cities where the amount of work available and the size of the advertising budgets can underwrite the efforts of support personnel. Indeed, you are unlikely to be given the type of assignment described above except in a large city. Nonetheless, you should be familiar with these people and how they work in anticipation of that first large assignment when you will be required to test to the limits your ability to handle a difficult assignment.

GENERAL GUIDELINES

No universally accepted rules govern the working relationship between you and your suppliers. The relationships we describe here are typical, but depending on your own situation and needs, you may need to strike your own agreements. The potential for misunderstandings is great, and you will ultimately be responsible for any that occur. Therefore, be sure to establish the ground rules with each supplier well in advance of a shooting.

Be aware also that a supplier can destroy a shooting. For example, if you send your film to an unreliable lab for processing and they mistakenly throw your film in the wrong chemicals, your client is going to blame you. Choose your suppliers with care.

The larger the city in which you work, the easier it will be to find suppliers. Check in the Yellow Pages to find those you need. Even better, if you list your name in the Yellow Pages under "Photographers," suppliers will then find you.

A tactic to use if you do not know the names of people to hire for a shot is to ask the client if there is anyone in particular he likes to work with. Often, he will suggest the names of people with whom he has been satisfied in the past.

Two other sources for the names of suppliers are *The Madison Avenue Handbook* and *On Location*, both of which were mentioned in the last chapter.

Your suppliers must watch their cash flow just as you must, and they may even try to manipulate you into carrying expenses that are rightfully theirs. Your only obligation is to pay them punctually. You are not obligated to foot the bill for their expenses. For example, if you hire a stylist, you should explain that as soon as you are paid and the check has had a chance to clear, he or she will then be paid, but not before.

Be sure to pay your suppliers promptly as promised. Many photographers think that delaying payment as long as possible is a good business strategy. You would be foolish to follow their lead. In essence you are borrowing your suppliers' money, which will certainly make them resentful. The more forthrightly you deal with your suppliers, the happier they will be working for you and the more willing they will be to help you when you really need it. Treat your suppliers shoddily, and they will undermine you and can actually do you great harm. Good, reliable suppliers are difficult to find and worth cultivating.

Great danger lies in accumulating in your bank account money that actually belongs to others. Money that is present in an account tends to be spent. Many photographers have fallen hopelessly in debt because they did not pay their suppliers promptly and then spent the money elsewhere. You cannot afford to let the same thing happen to you. Your reputation will suffer, your sleep will be uneasy, and you could end up in court.

The following is a list of the various suppliers you may need to use and guidelines for dealing with them.

PROPS AND PROPPING

Props can be critically important to a photograph. The right prop sets a certain visual tone that can elevate a mundane subject to something that seems beautiful and valuable. In some situations, the prop is almost more important to the photograph than its main subject.

In some cases a client may provide the props for a shot, but in most instances you will have to arrange for props yourself. Early in your career you should start to develop a list of stores that supply items that you may need someday for props. Antique stores, well-stocked hardware stores, clothing shops, a source for dry ice or costumes or plastics—the range of stores you might have to draw on is immense.

When propping a photograph, some items you will have to purchase, but others you may be able to rent. Approach the manager and explain who you are and what you want to do. Even stores that have never considered renting will usually be willing to let you use an item for a day or so for anywhere from 10 to 30 percent of the item's list price. Be prepared to leave a deposit equal to as much as 50 percent of the item's retail purchase price. Of course, you must return the item promptly and in pristine condition after you are finished with it.

You can save yourself a substantial amount of time and effort by tracking down as many of the props you need over the telephone. No matter how obscure an object may be, chances are that through the Yellow Pages you will be able to locate it or at least learn where to look. It makes little sense to spend hours on foot when a few simple phone calls can accomplish the same end in a small portion of the time.

Suppliers that specialize in finding all the props necessary for a shooting are called "stylists." You should hire a stylist to look for clothes for a model, to find antiques that you want to use, and generally to locate anything at all that you might need.

The real value of stylists is in their ability to find things fast, even when the request is highly unusual. Since commercial photographs usually are taken four to six months before they will be seen by the public, the props needed for a shot may be very hard to locate on short notice. Imagine the difficulty you would have trying to acquire a selection of bathing suits in November or Christmas ornaments in July. A good stylist will have developed an extensive list of resources and not only will be able to find objects out of season, but will have access to some items—original designer dresses, for instance—that you might not be able to obtain on your own.

During a shooting a stylist is responsible for overseeing the props and making sure that nothing is out of place. She (most stylists are women) will take care of any ironing that needs to be done and will watch to see that clothing is hanging properly on a model. If you do not have a hairdresser on duty, the stylist will also monitor a model's hair to make sure that all strands are in place.

Professional stylists are mostly to be found in large cities and are paid from $150 to $400 per day. To find a stylist you can check the Yellow Pages or *The Madison Avenue Handbook*. Of course, if the need arises, you can hire anybody at all to search for props, but you will achieve the best results if you work with someone who is specifically familiar with the needs of photography. A good photographic assistant can be trained to prop a shooting effectively.

If you are the one who hires the stylist, you must carry the various purchases and rental fees yourself until you receive reimbursement. If the client engages the stylist, the expenses are billed directly to him or her.

HAIRDRESSERS AND MAKEUP ARTISTS

When you are working with models, their hair and makeup must receive special attention. Most models are prepared to apply their own makeup and prepare their own hair according to the instructions you give, but for the best results, you should engage professionals.

Be sure to hire only people with experience in preparing models to be photographed. Personnel from the local beauty salon will not be satisfactory. Beauty parlor personnel are not accustomed to working under the time constraints that exist when an entire entourage of people associated with a shooting are poised to begin work, but must wait while the model is being readied. Moreover, hair and makeup styles that appear fine in person look different on film. As long as the model is an experienced professional, you are better off letting her prepare her own hair and makeup than relying on hairdressers and makeup artists without photographic experience.

If you should be given an assignment involving a model before you feel completely competent for the task, by all means find the most experienced hairdresser and makeup artist you can (often, the same person does both). You will only need to give general directions, and the person or persons you have hired will be able to take over from there.

SET BUILDING

The great advantage of working in a studio is that the environment lends itself very well to constructing artificial settings that look perfectly natural to the camera.

The most important principle to follow when building a set is that you never need to build more than the camera can see. Moreover, *you* control what the camera sees. The idea is to build, paint, and photograph only what you have to. For example, if only a small section of a wall will appear in a photograph, then that is all you need to work on. Anything that will be outside the view of the camera you can ignore.

Another important principle is to make your set as light in weight as you can. Light sets are easier to construct, easier to move around, and easier to disassemble. All you need care about is what the final result looks like. For example, suppose you have to photograph a model standing in front of a wall. You could buy plywood and 2 × 4s and build an actual wall, but to the camera, you could achieve the same effect by hanging some colored seamless paper in the background. To add authenticity,

you could attach the face plate of a wall socket to the paper and hang a painting by poking a hole through the paper and attaching the painting to a wire suspended from the ceiling. Because the camera does not detect texture, if the wall needed to be made of tile, as in a bathroom, all you need to do is attach ordinary contact paper with a tile design to a sheet of thin plywood. The bywords are ingenuity and imagination.

Set construction is billable to the client. You charge for materials plus labor. If you do the work yourself or have your assistant do it, you should charge at least as much as a carpenter or professional set designer would charge for the same work.

PROCESSING LABS

Portrait photographers make their profits from the prints they sell. Assignment photographers make their profits from the creative value of the image itself. As an assignment photographer, you should think of processing and printing not as money-making elements of your business, but as a critically important step in completing your obligation to your client.

You can process black-and-white film yourself or send it out. The advantages of doing it yourself are speed and quality control, but if you cannot afford the time and the local lab is competent, there is no reason not to use it. Most labs provide rush service for an extra charge. If you are a regular customer, they will usually do their best to be accommodating.

Color film is usually best handled by commercial labs, although if you want to you can do the processing in your own darkroom. Kodachrome film, however, must be processed by special machinery and chemicals. Until recently, only Kodak had the required materials, but lately, other labs have started to offer the service, also. Because Kodak will process film overnight if it is hand delivered, in cities with large populations of photographers, messenger services have been established to drop off Kodachrome on one afternoon and pick it up the following morning.

The costs of film and processing are billable to the client. Even for film that you process yourself, you should bill processing at the rate commercial labs charge. Otherwise, on those occasions when you must use the lab, the client will wonder why suddenly the charges for processing have changed.

Commercial processing labs are listed in the Yellow Pages. Visit the ones in your area, identify yourself, and find out about the services they offer. Before you trust any film shot on assignment to an individual lab, send it some test rolls. Examine the results for scratches and consistency in color rendition and contrast. Settle on one lab with which you can establish a good working relationship, and then try to give them enough business so that you become a valued customer.

CAMERA REPAIR

Small, independent camera repair shops not affiliated with any particular manufacturer are risky to use unless you are sure the shop's repair people are competent. You are much safer using a facility authorized by the manufacturer to repair your brand of equipment.

Nikon has established a repair system of great value to professional photographers. NPS (Nikon Professional Services) membership entitles you to high-priority repair services on your Nikon equipment. To apply, write Nikon Professional Services, Nikon, Inc., Garden City, NY 11530. You will receive a questionnaire to fill out. When your membership is accepted, you will be issued an identification card and a special sticker. Any time your camera or other item of Nikon equipment needs repair, if time is of the essence, affix the sticker and carry, mail, or ship the item to the nearest Nikon repair facility. It will be repaired on a priority basis and returned to you by the fastest possible method. If you use equipment manufactured by a company other than Nikon, write and ask that company if a service similar to NPS is available.

No matter who manufactures your camera, you should at all times carry with you a list of repair facilities. A postcard to the manufacturer will yield a list of authorized repair facilities around the world.

MESSENGERS

In the larger cities messengers are often routinely used instead of the mail. A good messenger service is much faster, more reliable, and not much more expensive.

Messenger services typically limit the liability they assume when transporting letters or packages. Find out from the service what its liability limit is, and then declare any item of higher value. You will have to pay an insurance fee for the additional value, but the extra expense protects you in case the messenger is robbed or becomes careless. If the messenger loses or damages your exposed film, you cannot collect more than the value of the new film, but a word of caution to the messenger that the contents of your package are valuable may induce him or her to exercise care.

MODELS AND MODEL AGENCIES

Depending on the type of photography you do, you may use models all the time or never at all. If you are not accustomed to working with models, the prospect can be intimidating. However, if you follow some basic principles, even your first shooting should go smoothly.

A tremendous difference exists between professional models and amateurs. Just because a person is beautiful is no guarantee that she will make a good model. (You are far more likely to work with female models than male models, so we will use female pronouns to refer to models.) Indeed, a professional model must work for years to become adept at her craft.

Professional model fees of $150 per hour and more may seem outrageous, but, in fact, they are quite reasonable if the model is skilled. There is only one goal in a shooting: to obtain a usable image. Experienced, professional models are so adept that they can deliver in one hour what someone with less skill may not be able to deliver in an entire day.

If the art director you are working for wants to use his daughter or his friend's daughter or his girl friend for a shooting, there are a few arguments you can use to try to

convince him otherwise. Point out that the body proportions that are considered attractive in everyday life usually do not photograph well (everyone knows how skinny models tend to be). Explain how using an amateur will probably waste time and cost extra money. Note that experienced professionals know exactly how to emphasize their strong points while hiding their deficiencies. Describe how important it is for the model to know how to position her body relative to the camera to minimize the distorting effect of lenses. Emphasize that if you have to pay too much attention to the model, you will not be able to devote enough attention to the client's product. Try anything else you can think of. Almost anything is better that trying to work with an amateur in a professional situation.

In the past only the very best models at an agency received the top hourly rate. Lately, the trend has been for the agencies to charge almost the same fee for all their models, from the most experienced to the least. As a result, there is nothing to be gained by hiring anyone but the best models an agency has to offer.

BOOKING PROFESSIONAL MODELS

When an art director indicates he or she wants models in a shooting, there is a progression of steps to follow.

Identify the agencies likely to represent the type of model you want • The main division in agencies is between those that represent models suitable for illustration photography (so-called real people agencies) and those for fashion/beauty photography. Most large cities will have both types.

Every model agency publishes a "head sheet"—a collection of photographs of the faces of the models it represents—which an agency will send you on request. Early in your career you should contact all the agencies in your area and start a head sheet file. When you have an assignment, you can request updated head sheets from those agencies that represent the type of model you are looking for. (After you become known in the industry, you will receive head sheets automatically in the mail.)

Select individual models • On the basis of the photographs on the head sheets, call the agencies and request the "composites" of those models that look promising. A composite consists of one or two printed pages containing photographs from an individual model's portfolio.

Arrange for a go-see • Never commit yourself to using a model on the basis of her composite. The composite represents only the very best photographs that have been taken of her. More important, people change. Her hair may now be different, she may have gained weight since the time her composite photographs were taken— you never know unless you look. This is especially true with children.

Once you have narrowed the number of possibilities, tell the agencies involved which models you would like to see and when they should come. If possible, try to have the client present during this "go-see" session. Otherwise, narrow the possibilities to three or four and arrange for them to go the art director's office so that he or she can make the final choice.

Make a tentative booking • Once you have decided on the model you want to use and the date you want to use her, call the agency and book a "tentative" on her, if she is free. The tentative obligates the agency to contact you if the model is subsequently requested by another photographer for a conflicting time. You are free to cancel a tentative without incurring any fee.

If the model has already been tentatively booked by another photographer, you will be offered a "secondary," meaning that if the tentative is cancelled, you will be contacted and given an opportunity to book the model.

Convert the tentative to a definite • Once you are absolutely certain that the shooting date is firm, you can convert the tentative to a "definite." Delay as long as you can, however. As soon as you have booked a definite, cancellation will result in anywhere from a half- to a full-fee cancellation charge, depending on the policy of the particular agency. Delaying the conversion preserves flexibility for you as long as possible.

If the success of the shooting depends upon a particular type of weather, you can book a "weather permit." This means that if the weather you designate does not occur—sun, snow, rain, whatever—you can cancel with only a half-fee charge. However, you must again book the same model at full-fee to be eligible for the reduced cancellation fee.

FEES

Models are paid by the hour, by the half-day, and by the day. Time spent by the model for makeup or hairdressing is usually billed at full rate. Extra charges are usually imposed for any time the model works before 9:00 A.M. and after 5:00 P.M. Rates are usually higher for modeling lingerie. In addition, substantial bonuses must be paid if the photograph will be used in a national ad, on packaging, or on point-of-purchase displays.

You should describe how a photograph will be used at the time you make the booking and find out exactly what the fees and bonuses will be. Be sure the client has this information before you make the booking definite. Models fees are billed directly to the client by the model agency.

MODEL RELEASES

Without exception, any time that a living person is recognizable in a photograph that will be used commercially, you must obtain a valid model release from that person granting you permission to use his or her image. To shirk your obligation to obtain releases is to court invasion of privacy lawsuits.

The model release shown on page 157 will be sufficient to allow you to use a person's image commercially. With professional models the release will be incorporated into the agency voucher you sign after the shooting. ■

RELEASE

I hereby irrevocably consent to and authorize the reproduction, publication, and/or sale by [your name], his licensees or assigns, of the photographs identified below, in whole or part or in conjunction with other photographs, in any medium and for any lawful purpose, including illustration, promotion, or advertising, without any further compensation to me.

I waive any right to notice or approval of any use of the photographs which [your name] may make or authorize and I release, discharge, and agree to save [your name] or his licensees or assigns from any claim or liability in connection with the use of the photographs as aforesaid or by virtue of any alteration, processing, or use thereof in composite form, whether intentional or otherwise.

Description of Photograph(s):

Name and address

Date

Signature (of parent or guardian if model is a minor)

ANATOMY OF AN ASSIGNMENT

12

In some ways every assignment is unique, but at the same time, every assignment is somewhat the same. Each time you execute an assignment you will be encountering new problems and challenges, but you will also be developing a reservoir of experiences that you can draw on repeatedly to help you in the future. After having completed a surprisingly small number of assignments, you will discover that shots you at one time might have labored over for hours suddenly require only minutes to complete. You will have developed the proficiency that one truly associates with the word "professional."

In this final chapter we will describe an assignment that one of us (Tom Grill) actually executed. The client was L'Oreal, the international cosmetic company. Although you are unlikely to encounter exactly the same combination of requirements, complications, problems, and solutions in any of your assignments, the overall process will be similar, no matter what the task and no matter its scope. We hope that in the course of reading about this assignment you will experience a little of the flavor of assignment photography—the excitement, the frustrations, and the satisfactions that lie ahead of you when you pursue assignment photography as a career. The following description of the assignment was compiled from notes made as the shooting progressed.

Monday • Milt Pilowski, one of the art directors at L'Oreal, calls to describe an assignment they want to shoot for a point-of-purchase display. The title of the campaign is "Sea Fleurs," and the goal is to promote a line of cosmetics L'Oreal has developed that are designed to be resistant to the effects of water. The concept of the display is to create a feeling of fantasy in a photograph and simultaneously convey the ideas of "wetness," "flowers," and "beauty." The shot Milt has in mind takes

place underwater with the model surrounded by flowers and dressed in a long flowing gown. He wants to shoot two weeks from today.

Tuesday • After thinking about the assignment overnight, I call Milt in the morning to discuss that shot further. I haven't seen any drawings yet, but I have some definite thoughts that I want to talk over with him.

The first point I make is an underwater beauty shot is really tricky. First of all, the deeper you go, the bluer light becomes underwater. To get the exact color he wants, he may have to retouch the photograph—not really a problem because I know from past experience that Milt's retoucher is excellent.

I suggest the possibility of shooting entirely in a studio. I could place the model in front of a neutral background and shoot through a fish tank to give an underwater effect. This photograph could then be inserted into a separate shot of an underwater scene. The problem with this approach is that there is no way of knowing in advance whether it will actually work.

Milt feels that it makes more sense to shoot on location. I warn him that the odds of getting the shot are rather slim. So many variables must be controlled that there is a good chance that the underwater shot he has in mind will not work out. I suggest that we take the general theme of a fantasy scene and plan to shoot it *above* water. We will try to get the underwater shot as a bonus. If it works, fine, but if not, we will have the other shot to rely on.

We discuss a location. Florida won't work because of murky water and poor beaches, so the Caribbean seems like our best bet. We decide on St. Thomas in the Virgin Islands. The water is clear, the beaches are beautiful, and the island is well-enough developed so that we don't have to worry about our ability to purchase props locally and get the type of support we will need to go scuba diving.

Then, I spend some time preplanning the trip and making up a list of everything we will need and must do, both here and when we get to St. Thomas. In the afternoon I make a few calls to the island's Chamber of Commerce and speak to a woman named Ginny. She is extraordinarily helpful, and as I run down the list of things I

know I am going to need, she tells me which I can get locally and which I can't.

Of all the things I will need for the shot, three are especially important: orchids, a diving team, and a cabin cruiser. The orchids I need because we have decided to surround the model with dozens of them. I must be sure that if we can't get them on the island, we have time to make other arrangements. Ginny checks around and assures me that the 200 orchids I will need will be readily available.

The diving team I need because even though my assistant and I are certified divers, the other members of our group are not. For safety's sake, and also just to lend general assistance, I insist on having other qualified divers on hand.

The cabin cruiser I need because of the requirements of our main shot. We won't know exactly where we are going to shoot until we arrive on the island and have a chance to look around. The cabin cruiser will enable us to search around on the shores of St. Thomas and the other islands in the area to find the best locations to use. In addition, we need the boat for a slightly bizarre but very practical reason: in the hot, humid climate of St. Thomas a model's hair falls quickly. The boat will provide a source of electricity for the model's hot curlers so we can reset her hair as often as necessary. In addition, the boat will serve as a changing room and a place for warming up after hours of being in the water.

Wednesday • I receive some interesting news. Deborah Halley, the model we must use for the shooting because she is under long-term contract with L'Oreal, can't swim. The minor panic that ensues is relieved when Deborah assures us that she's not afraid of the water and has no reservations at all about doing the shot. Sighs of relief all around.

Thursday • I put my assistant, Michael Stuckey, on the phone to arrange accommodations and make the necessary reservations. Again, he receives excellent guidance from Ginny at the Chamber of Commerce. We have decided that Michael, Milt, Nancy (the L'Oreal product manager involved), and I will go down on the Friday

preceding the shooting, with Deborah to follow on Sunday evening. Michael books us all in a hotel and checks to make sure that it will have an iron and ironing board available that we can use to touch up Deborah's clothes after her flight.

Because Milt and Nancy have no experience diving, I recommend that they spend Sunday taking diving lessons. The lessons will prepare them so that they can go underwater with me—under the supervision of the diving team we have hired, of course—and keep an eye on the shooting. I always like my clients to be able to make recommendations during the course of a shooting. Michael arranges for the Sunday lessons, as well as for a diving team and two diving boats on Tuesday afternoon.

Friday through the following Thursday · Michael and I take care of all the predeparture preparations. I hire a stylist to pick up a selection of rings, bracelets, and other items of jewelry we are going to need. The rest of the needed styling we will do on our own once we get to the island. Because Deborah is very proficient at preparing her own hair and makeup, we decide not to bring hair and makeup artists with us.

Michael checks over all the equipment and packs everything carefully. Even though I know we can buy Kodachrome in St. Thomas, I have him pack 80 rolls to be safe. Just in case something goes wrong with the flowers, I check to be sure that enough are available in New York so that in an emergency I can have them picked up and sent down on short notice. I check with everyone involved in the shooting to make sure I have phone numbers where they can be reached night or day.

Friday · Friday morning I have a limosine pick everyone up. We have so much gear that we need the extra space, and the cost of the limo out to the airport is less than the cost of a rental car for such a short trip. By arranging for all of us to go together, I am sure that nobody will miss the plane. The group consists of Michael, Milt, Nancy, and me.

After an uneventful flight, we arrive at St. Thomas and I rent a car. As soon as we reach the hotel—about 5 P.M.—I call Ginny at the Chamber of Commerce office

to arrange for a meeting time the next morning. Ginny, however, insists on coming over to the hotel to help us plan the next day in detail. Guided by Ginny's suggestions, we organize the following day's activities.

Saturday • Right away, a minor problem develops. We have located the exact boat we need for Monday's shooting, but the owner won't accept charge cards or checks. It's cash in advance or find someone else. Fortunately, we have enough travelers checks to cover the $450 he wants to charter the boat for a day.

Next on the list are the various props we are going to need. The most important are the orchids, but in order to keep them as fresh-looking as possible I don't want to pick them up any earlier than I have to. However, I decide that I had better take a look at what is available to make sure they are in good condition. The first shop I go into doesn't carry orchids. Nor does the second. It turns out that there aren't any orchids on the entire island.

Back to the hotel to the phone. A few orchids can be had from Puerto Rico, but not enough. None are to be found on St. Croix. All we need are in Miami, but no plane is scheduled to St. Thomas in time to get them here for the shooting. And we can't delay the shooting because Deborah has another booking that would conflict.

I call my contact in New York and tell him to round up 200 orchids, fast, and to meet Deborah at the airport tomorrow so that she can bring them down with her.

Nonetheless, I figure that I had better be sure I have an alternative in case the flowers freeze in the baggage hold or something else happens. During the rest of the day I stop everywhere I can and look at flower selections. By chance, I see a streetside flower vendor selling a beautiful yellow flower—a type of lily, I think—that I have never seen before. How many does she have? About a hundred? I take them all. Back to the hotel to fill the bathtubs with ice to keep the flowers cool.

Out in town, again, I continue looking for props. Some aren't available, but I have far more than I really need, anyway. I'm not worried. Another chore I carry out is to confirm the scuba lessons for tomorrow, as well as the diving boats and team for Tuesday afternoon.

While we are there, I have Milt and Nancy outfitted for diving and rent the few items of diving equipment that Michael and I need but didn't bring along.

Sunday • Sunday is a purposeful but somewhat leisurely day. I knew that most of the stores would be closed, so while Milt and Nancy take their diving lesson, I have arranged to hire a small boat to take Michael and me around the island and nearby St. John to look for shooting sites. We make note of areas we will want to return to on Monday, when we have the cabin cruiser and everyone along for the actual shooting. We find a number of promising sites and select one that we think will be best.

Sunday evening Deborah arrives with the orchids in tow, and all are in nearly perfect shape. Each of the rooms we are in contains a refrigerator, so out goes everything to make room for the flowers.

That evening we have a preshoot meeting. I explain that we must be in place and ready by the time the sun peeks over the horizon. That means leaving the hotel as soon as the sky begins to lighten. Sunrise is at 6:30, so everybody has to be ready to leave the hotel by 5:00.

Monday • I awake at 4:00 A.M. to the sound of raindrops pounding on the roof. The sky is too dark to allow me to see the clouds, but I am hopeful that this is just a typical, short-lived tropical storm that will leave a clear sky behind. I'm not too worried.

By 5:00 the rain has stopped, but the sky is still too dark to read. We load the car and head out to the boat, just in case. We transfer everything to the boat and sit down to wait until the sky lightens enough for us to make an accurate evaluation of the severity of the storm.

By 6:45 it is obvious that the cloud cover is unlikely to clear up soon. I cancel the boat and pay the skipper a $150 cancellation fee.

While the rest of the group eats breakfast back at the hotel, Michael and I scout the beaches in the vicinity of the hotel for a location we can use should the clouds break even for just a few minutes. The big problem is Deborah's hot curlers. We must be close enough to the hotel so that she can reset her hair whenever necessary.

Luckily, we find two spots that look good. Both are small coves, sort of mini-lagoons. By choosing the right camera angles, I can make the two sites appear desolate. No one would guess that a major hotel complex was only a few hundred feet away.

At midday the sky begins to brighten. Normally, the tropical sun is so strong that shooting is impossible except for an hour or two around sunrise and sunset. But by noon a thin cloud cover is allowing plenty of light through, though not so much that I can't shoot.

I gather everyone together and we move out to the first site. For the next three hours we shoot constantly. I have no way of knowing how long the sky will stay light, and for all I know this will be my only chance to fulfill the assignment. I am determined to get at least one usable shot during this session.

To compensate for the lack of a strong sun, I use reflectors placed low to direct light from the sky onto Deborah's face. To warm up the light, I line the inside of the reflectors with strips of gold foil.

Deborah is marvelous. The water is cold and a breeze is blowing, yet she spends hour after hour in the water without a murmur of complaint. By the time we are ready to leave, I am convinced that even if we have no other opportunity to shoot while we are here, we've still got a shot we can use.

The sky is looking better all the time, so I decide to go for a shot against against the setting sun. I have a conch shell and I want to try for a silhouette of Deborah holding the shell aloft and pouring water from it onto her face. I need a location that has palm branches in the background, both to say tropics and to compensate for the lack of the sun should it be hidden behind clouds. I find the perfect spot right on the veranda of the hotel.

This second shooting of the day goes fine. When I go to bed, I sleep comfortably.

Tuesday • Today, we arise to a clear sky and the promise of a beautiful day. In the afternoon the dive is scheduled, but we have nothing specific planned for the morning. I decide to return to the same general area we used yesterday. I had noticed a sandy beach with large

rocks protruding from the water that I thought might look good. Whereas yesterday we could take our time, today we have only a brief interval between sunrise and when the light will become too harsh to shoot in.

Again, Deborah holds her own against the cold. This early in the morning the air is brisk, but she gamely immerses herself in the water again and again. When I am shooting on location like this, I usually try to involve everyone. So while I shoot and Michael keeps my cameras loaded, Milt and Nancy work to keep Deborah surrounded with flowers. We have pinned orchids all over her bathing suit, and as she lies in the water, Nancy gathers handfuls of flowers and passes them to Milt, who throws them all around her. With each wave the orchids shift and drift, so the two of them must constantly fish flowers out of the water and position them again. We only shoot for about a half hour, but it's a period of intense activity and concentration for all of us. Nonetheless, it's actually kind of fun.

For the next hour or so we return to the previous day's sites and reshoot. I'm not too optimistic about the results, though, because the light is very harsh. By 10:00 the light is simply unusable, so we return to the hotel for a belated breakfast.

From noon to 1:00 we load the diving boats with our gear. I know that the shooting is a success even if this shot doesn't work out, but still, I'm excited by the challenge. If all goes well, this shot could be really exceptional and make the assignment a rousing success.

Because of Deborah's inability to swim, I want a place that is not too deep. Anyway, the nearer we are to the surface, the truer the colors will be and the more light we will have. I figure that we need about 6 feet of water over her head.

I choose a site that is fairly deep, but that has a coral ledge at about 6 feet below the surface for Deborah to hold onto for security. We put a weight belt around her waist under her gown, so all she has to do is hold on lightly to the coral to stay submerged and stable.

My Nikons are protected from the water by underwater housings. Because loading film involves taking the

camera to the surface, I have rented a third camera so that I can preload all three. I don't expect to be able to take many frames while underwater, and the third body may enable me to avoid having to reload film at all.

The housings have "dome ports"—optically ground glass that extends the depth of field of the camera lens to between 1 foot and infinity. This is important because focusing is extremely difficult underwater. The different refractive index of water makes the distance measurements on the camera lens inaccurate, the split image in the viewfinder is often impossible to read, and the current keeps the distance between photographer and subject constantly changing. With the dome port, I don't have to worry about focusing at all.

I decide to shoot with a 20mm lens. The short lens, aside from having a broad depth of field, allows me to move close to my subject to minimize the diffusing effect of the water. This way, my colors are more saturated and detail is more distinct. Because of the water, the effective focal length of the lens is actually closer to 28mm.

The shooting itself requires intricate timing. Deborah, at the surface, must fill her lungs with air, after which one of the divers pulls her under into position and then swims away. Meanwhile, a second diver, located about 10 feet below, must release orchids at exactly the right instant so that they are floating up around her while I am taking the shots. I'm not sure it's going to work, but we give it a try.

On the first attempt, Deborah comes down holding her nose. A perfectly natural impulse, but a poor reflection on the product we are trying to promote. I surface and speak to her briefly, and during the rest of the time she does fine.

Each submersion is very taxing on Deborah, but she manages to complete a surprising number of cycles. With each dive I have time for only three or four exposures. By the time she is utterly exhausted, I have shot a roll and a half of film. But unless something unexpected has occurred, I'm sure we've got the shot we were looking for.

That's it. A "wrap" as they say in the movies.

These photographs are a sample of the
various images obtained during the
L'Oreal assignment in St. Thomas. My
goal at all times was to cover my bases. By
treating each different shooting as if it were
going to be the only chance I would have to
fulfill the assignment, I made sure that I
left St. Thomas with at least one usable
image.

Although the basic assignment was to
combine the themes of wetness, flowers, and
beauty, occasionally I would take a few
straight beauty shots, just in case the art
director might be able to use them.

As soon as we return to the hotel, Michael and I go over the equipment carefully to remove any salt residues and to blow out any sand. Surprisingly, the equipment doesn't look too bad, considering the conditions we were working under. Also, we account for every roll of film. We divide the film from each site in half, and he takes one bag and I the other. For the rest of the time until we get the film back from processing, the two batches will be handled and treated separately.

When we are done, we join the others for a sort of victory celebration.

Wednesday • Preparations for departure are routine. Michael and I double-check the film and store it in the bags we will carry with us on the plane. When we arrive back in New York a limosine is waiting to return us all to our offices. Michael immediately turns in half of the film for processing.

Thursday • In the morning we send in the other half of the film for processing.

Friday • As soon as the film is back, I start to edit it. I remove all the brackets and the obviously unusable photographs and select out the ones from each shooting that look best. I find a few frames that I would like to keep for possible use in my portfolio. Fortunately, the ones I want have almost identical duplicates, so I can retain them without depriving the client of the opportunity to see them.

The following week • Milt contacts me toward the end of the week. After he looked them over, he liked the ones from the underwater shooting best. However, it turns out that the representative from L'Oreal preferred one from the session taken at sunrise on the second morning, so that is the one that will become part of the point-of-purchase display. He's as pleased with the shooting as I am, so everything looks okay. It was a difficult assignment, but fun, and the client is happy with the results. What more could I ask for? ■

L'ORÉAL INTRODUCES Les Seafleurs

A FANTASY IN LIGHTS AND FLOWERS

L'ORÉAL... "THE NEW SPIRIT OF CHIC"

Although the art director liked one of the underwater shots best, his *client eventually decided to use the photograph above in the point-of-purchase display. This was one of the shots taken on the morning of the second day of shooting. The remaining photographs from the shooting will in all likelihood never be used.*

At right are listed some of the better books available containing information you will find useful as you start your professional photography business. Some are difficult to find in stores, but all can be purchased by mail directly from the publisher. If you order by mail, be sure to enclose an extra 15 percent of the selling price to cover the cost of postage and handling.

ANNOTATED BIBLIOGRAPHY

Cook, Geraldine, ed. *On Location: The National Film and Videotape Production Directory.* On Location Publishing, Inc., 6311 Romanie, Hollywood, CA 90038. $25.00. Discussed on page 142.

Covallo, Robert M., and Kahan, Stuart. *The Business of Photography.* Crown Publishers, Inc., One Park Avenue, New York, NY 10016. $10.95. Contains a particularly good collection of forms that a beginning photographer might need. The discussion of sales and use taxes is very helpful.

Glenn, Peter, ed. *The Madison Avenue Handbook.* Peter Glenn Publications, Ltd., 17 East 48th Street, New York, NY 10017. $20.00. Discussed on page 141.

Kopelman, Arie, and Crawford, Tad. *Selling Your Photography: The Complete Marketing, Business and Legal Guide.* St. Martin's Press, 175 Fifth Avenue, New York, NY 10010. $13.95. Part III, Legal Guide, is especially useful. Good selection of model release forms for different specialized needs.

Scanlon, Henry. *You Can Sell Your Photos.* Harper & Row. $7.95 (paper). Available by mail only from Radial Press, Inc., 32 East 31st Street, New York, NY 10016. Without question the most comprehensive guide to stock photography available. The last chapter on stock photo agencies and contracts is must reading for every professional photographer.

Stockwell, John, and Holtje, Bert, eds. *The Photographer's Business Handbook.* McGraw-Hill, 1221 Avenue of the Americas, New York, NY 10036. $14.95. This book is a collection of essays of uneven quality on various photography-related topics. Some of the essays are useful, especially those dealing with finances.

INDEX

Accessories, 122, 125
Accountant, 40
Accounting, 49–61
 books, 50–51
Accounts
 chart of, 51–52
 receivable, 57
Advertising, 79
Agents and studio leasing, 128
Annual reports, 20
Answering services and
 machines, 36–37
Appointments, 81–82
Architectural photographer, 20
Art directors
 arranging appointments
 with, 81–82
 describes shot, 159–160
 during shooting, 89–90
 interview with, 82–84
 negotiating fee with, 84–87
Assignment photography,
 9–11; see also
 Professional photography
Assistant, 28–29, 133, 134
Attorney for studio leasing,
 132

Bank reconciliations, 53
Better Business Bureau, 43
Black and white film, 121
Bookkeeping, 49–61

Cameras, 117–120
 brands of, 120
 repair of, 153
 in underwater shot,
 166–167
Cash
 disbursements, 53, 55
 flow, 56–59
 receipts, 52, 55
Chamber of Commerce, 43
 and shooting on location 161
Character of professional
 photographer, 13–15
Checklist in shooting on
 location, 137
Clientele, 30–32, 81–93
 billing of, 92
 providing extra service
 to, 32

in shooting on location,
 138
Collection agencies, 60
Color film, 121
Commercial
 assignments, 18
 look and portfolio,
 66–68, 71–73
 photos in portfolio, 65
 self-assignments for
 portfolio, 68–71
Corporation as legal form of
 business, 40
County clerk, 43
Creative opportunities of
 assignment photography, 10
Credit, 44–46
 cards, 45–46
 history, 45

Darkroom, 130, 133
Day rates, 84–85
Deferred compensation plan, 42
Delinquent accounts, 59–60
Depreciation, 50
Depth of field, 118
Dividend payments, 42
Double-entry bookkeeping, 51

Editing shots, 91–92, 170
Editorial assignment
 photography, 18
Employer's Identification
 Number, 43
Equipment, 117–125
 and clientele, 31
 lighting, 124
 new vs. used, 121–122
 reliability, 128
 rental, 122
Expenses
 billable and nonbillable,
 87–88
 and invoices, 32
 management of, 61
 running, 133–134
 in shooting on location,
 139–140
 startup, 132–133

Failure of shot, 92–93
Fashion/beauty photographer, 22
Fees
 for assistants, 29
 for models, 157
 negotiation of, 84–87
 for shooting on location, 139
Fields of photography,
 characteristics of, 21
Film, 117–118, 121, 162
 processing of, 152–153
 for shooting on location, 145
Financial
 base, 27–30
 equity and stock
 photography, 100
 return of assignment
 photography, 10
 statements, 56
Focus, 118
Format of shot, 118
Found money in stock
 photography, 100

Gratuities as studio expense, 134

Hairdressers, 150–151, 162

Illustration photographer, 22
Image of professional
 photographer, 35–39
Industrial photographer, 22–24
Insurance, 43–44, 134
Interior photographer, 24
Interview with art director, 82–84
Investment tax credits, 42
Invoices, 32, 57–58
 design of, 39

Job
 equity, 12
 estimates, 87–88
 satisfaction, 10–11
 sheets, 57

Key shots, 102

Large—format cameras, 119–120
Legal form of business, 39–42
Letterhead, 38
Lighting equipment, 124–125

Makeup artists, 150–151, 162
Medium-format cameras, 119
Messengers, 154
Models
 and model agencies, 154–157
 releases, 157
 for shooting on location, 161
 in studio assignment, 95–96
Monthly
 statements, 59
 summaries of accounts, 53

Nonphotographic talents and a
 career in photography, 18–
 19

Opportunities of photographic
 fields, 26

Partnerships, 39–40
Personal representatives, 46–47
Personality and choice of field,
 19–20
Photoflood lamps, 124
Photographer's assistant, 27–29
Photographic
 assignments, going rates
 for, 86
 fields, important
 characteristics of, 21
Photographs for portfolio, 68,
 71–73
Photojournalists, 24
Polaroid camera backs, 120
Portfolio, 63–77
 assembling, 68–73
 carriers, 77
 photos, selection of, 71–73
 presentation of, 74–76
 refinement of, 73
Prints in portfolio
 presentation, 75–76
Processing labs, 152–153
Professional photographer
 becoming established as, 12
 business goals of, 32–33
 business location of, 42–43
 character traits of, 13–15
 legal form of business of,
 39–42

Professional photography
 choosing a field in, 17–26
 drawbacks of, 11–13
Promotion, 78–79
Props and propping, 149–150,
 163–164
Punctuality, 32
Purchase order in shooting
 on location, 140

Quartz-Halogen lamps, 124

Refuse collection from studio,
 134
Reps, 46–47
 and marketing of stock
 photography, 110
Reshoots, 92–93
Running expenses, 133–134

Sales tax bureau, 43
Satellite shots, 102
Security and professional
 photography, 11–12
Self-assignments, 68–71
Set building, 151
Shoot
 failure of, 92–93
 preparing for, 88–89
Shooting on location, 137–145,
 159–171
 accommodations for, 142
 checklist for, 137–138
 client and, 138
 and film, 145
 finances of, 139–140
 selection of location for,
 100, 140–141
 and weather, 143, 164
Slides in portfolio presentation,
 74–75
Small claims court, 60
Sole proprietorship, 39
Sports photographers, 24–25
Square camera system, 123
Startup expenses, 132–133
Statements, design of, 39
Stationery and image of
 professional photographer,
 37

Still-life photographer, 25
Stock photo, 26
 agency, 113–115
 files, 107–109
 ownership of, 109
Stock photography, 99–115
 characteristics of, 103–104
 marketing of, 110–115
 moods and ideas in, 101–102
Strobe, 118, 125
Studio, 127–135
 assignment, diary of, 94–97
 lease vs. rental, 127–128
 renting day by day, 135
 size requirements of, 129
 subleasing of, 129
 view camera system, 123
Style and portfolio, 66–67, 73
Stylist, 95–96, 149–150, 162
Supplies
 for a shot on location, 100–101
 and suppliers, 147–157

Taxes, 42, 43, 60–61, 133
Tearsheets, 77
Telephone
 and delinquent accounts,
 59–60
 and image of professional
 photographer, 35–37
35mm
 camera, 117–118, 122–123
 slides, 74–75
Transparencies in portfolio
 presentation, 76
Travel
 and assignment photography,
 11
 photography, 26
 and stock photography, 102

Utilities in studio, 131, 133

Weather, 143, 164